C000216695

JACK GILLON & PAUL M^CAULEY

MONUMENTAL EDINBURGH

AMBERLEY

Dedicated to the memory of Gerry Whelan, who loved this monumental city.

First published 2015

Amberley Publishing
The Hill, Stroud
Gloucestershire, GL5 4EP

www.amberley-books.com

Copyright © Jack Gillon and Paul McAuley, 2015

The right of Jack Gillon and Paul McAuley to be
identified as the Author of this work has been asserted
in accordance with the Copyrights, Designs and
Patents Act 1988.

ISBN 978 1 4456 5007 4 (print)
ISBN 978 1 4456 5008 1 (ebook)

All rights reserved. No part of this book may be
reprinted or reproduced or utilised in any form or
by any electronic, mechanical or other means, now
known or hereafter invented, including photocopying
and recording, or in any information storage or
retrieval system, without the permission in writing
from the Publishers.

British Library Cataloguing in Publication Data.
A catalogue record for this book is available from the
British Library.

Typesetting by Amberley Publishing.
Printed in the UK.

Contents

1

Introduction

The stone unhewn and cold becomes a living mould, the more the marble wastes the more the statue grows.

Michelangelo di Lodovico Buonarroti

Lord Melville's Monument is most elegant to be seen,
Which is situated in St Andrew's Square, amongst shrubberies green,
Which seems most gorgeous to the eye,
Because it is towering so very high.

The Prince Albert Consort Statue looks very grand,
Especially the granite blocks whereon it doth stand,
Which is admired by all tourists as they pass by,
Because the big granite blocks seem magnificent to the eye.

Extract from 'Beautiful Edinburgh' by William Topaz McGonagall

Edinburgh has a long tradition of erecting statues, monuments and sculptures to mark important events and special people, which has left the city with an outstanding diversity of artworks in public spaces. All of them tell us something about the history of the city – like a museum collection, but on display in the parks and streets. They enrich the appearance of an area and make a positive contribution to cultural and community identity.

The tallest is the Scott Monument – 200 feet high (60 metres) with 287 steps. The oldest is the statue of King Charles II in Parliament Square, which dates from 1685. The most famous is probably Greyfriars Bobby. The most ambitious could be the National Monument on Calton Hill – it was never finished. The most controversial is most likely the memorial to Dr Hugh Dewar in Abercorn Park, Portobello.

Edinburgh has lost a small number of monuments over the years. The much loved Elm Row Pigeons were a pod of bronze birds which used to stand on the pavement at Elm Row. The ill-fated Kinetic Sculpture was an 80-foot-high (24 metres) 'spiral of kinetic art' which was unveiled in 1974 on a traffic roundabout at Picardy Place. The sculpture was less than enthusiastically received and became popularly known as the 'drunken pylon'. It seldom worked and was finally removed in 1983.

Others have been moved to ease traffic congestion. The William Gladstone Memorial, first erected in St Andrew Square, was moved to its current location in Coates Crescent some years later, and a drinking fountain once erected for cabmen and horses by Catherine Sinclair at the junction of Lothian Road and Princes Street was dismantled and partially re-erected at Gosford Place cycle path.

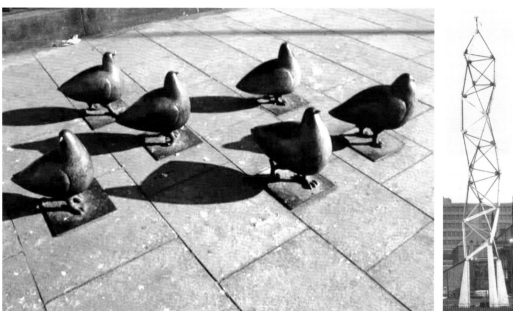
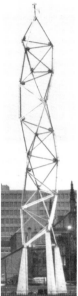

Many new monuments will no doubt be erected in the city in the future. At the time of writing, a statue of Wojtek, the Soldier Bear, is being erected in Princes Street Gardens.

All these monumental works were created by human endeavour to commemorate individuals and events. They all involved skilled artisans, who won the stone from Scottish quarries; bronze founders, who cast the metal elements; architects, who designed the structures and pedestals; and sculptors, who modelled the figures in marble, stone and bronze.

The Sculptors

Sir John Steell (1804–91) was born in Aberdeen, but his family moved to Edinburgh shortly after his birth. He showed early artistic abilities, and studied art in Edinburgh and sculpture in Rome. Steell imported enormous pieces of Italian Carrara marble for his depiction of Sir Walter Scott and also started the first bronze foundry specifically to cast statues. In 1838, he was appointed Sculptor to Her Majesty the Queen. Steell was knighted in 1876 by Queen Victoria, following the unveiling of his statue of the Prince Consort in Charlotte Square. It is ironic that Steell, who created so many of Edinburgh's great monuments, is buried in an unmarked grave in the family vault at Calton Burial Ground.

The Rhind family were significant sculptors of the late nineteenth and early twentieth century heyday of monuments in the city. John Rhind (1828–92) was born in Banff but became a sculptor in Edinburgh, after training under Musselburgh-born Alexander Handyside Ritchie – himself an eminent and prolific sculptor.

John Rhind created several statues mentioned in this book – the Genius of Architecture, William Chambers and the Catherine Sinclair memorial. John Rhind's sons were all involved in creating architecture and sculpture. William Birnie Rhind (1853–1933) contributed prominent regimental memorials for the city– the Royal Scots Greys, the King's Own Scottish Borderers and the Black Watch. James Massey Rhind (1860–1936) emigrated to America and created statuary there and Sir Thomas Duncan Rhind (1871–1927) became a respected architect.

Another lesser-known sculptor is John Stevenson Rhind, who was responsible for Queen Victoria at the foot of Leith Walk, Edward VII in Victoria Park and Tubal Cain on the Brassfounders column on Nicolson Square.

Robert Tait Mackenzie was born in Ontario, Canada, of Scots parentage. He created the Scots-American memorial in Princes Street Gardens which has fine character studies and is a poignant depiction of the men who responded to the Call to Arms.

Amelia Paton Hill (1820–1904) is one of very few women to sculpt statues in the city, notably that of David Livingstone, but she has been overshadowed by her pioneering photographer husband, David Octavius Hill, and her artist brothers Joseph Noel Paton and Hugh Waller Paton. She also made three statues for the Scott Monument.

The most prolific of the contemporary sculptors is the Queen's Sculptor in Ordinary, Alexander Stoddart, who has created statues of David Hume, Adam Smith, James Clerk Maxwell, and a memorial depicting characters from Robert Louis Stevenson's novel *Kidnapped*, as well as many others around the world.

Alan Heriot is another well-known figurative sculptor, who depicted Robert Louis Stevenson outside Colinton parish church and the most recent addition to Princes Street Gardens, Wojtek the Soldier Bear.

Old Town

Greyfriars Bobby Statue, Candlemaker Row/George IV Bridge

The bronze sculpture of the Skye terrier 'Bobby' sits on top of a column of polished Shap granite and is the most photographed statue in Edinburgh. William Brodie RSA (1815–81) designed the statue at the instigation of Baroness Angela Burdett-Coutts, the wealthy daughter of a former Edinburgh Lord Provost. The town council granted her permission to erect the fountain opposite Greyfriars Churchyard and it was unveiled on 15 November 1873.

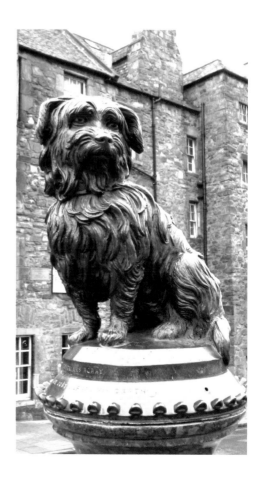

The main plaque on the fountain reads:

A Tribute to the Affectionate Fidelity of Greyfriars Bobby. In 1858, This Faithful Dog Followed the Remains of His Master To Greyfriars Churchyard and Lingered Near the Spot Until His Death in 1872. With Permission, Erected by the Baroness Burdett-Coutts. Greyfriars Bobby, From the Life Just Before His Death.

There are also bronze plaques with the coats of arms of Edinburgh and Burdett-Coutts.

The fountain has a lower drinking basin for dogs and an upper spout for humans. In 1957, the water supply was discontinued due to public health concerns.

Recently an urban myth has developed that rubbing Bobby's nose will bring good luck. This was started by a local tour guide and has resulted in Bobby having a rather unattractive shiny proboscis – we suggest that everybody leaves Bobby's nose alone.

Covenanters' Memorial, The Grassmarket

The Covenanters' Memorial in the Grassmarket dates from 1837. It is a roughly hewn raised cylinder with an inset granite circle and Saltire cross surrounded by a bronze circular inscription: 'Many Martyrs and Covenanters Died for the Protestant Faith on This Spot.' The memorial marks the place where over a hundred Covenanters were executed during the Wars of Religion (1661–68). The Covenanters opposed the interference of the Stuart kings in the affairs of the Presbyterian Church in Scotland. The memorial was first unveiled on 25 April 1937.

Old Town Wellheads

In 1674, the city's first piped water supply was instigated by Lord Provost Sir Andrew Ramsay. The work involved Sir William Bruce, architect of Holyrood Palace; George

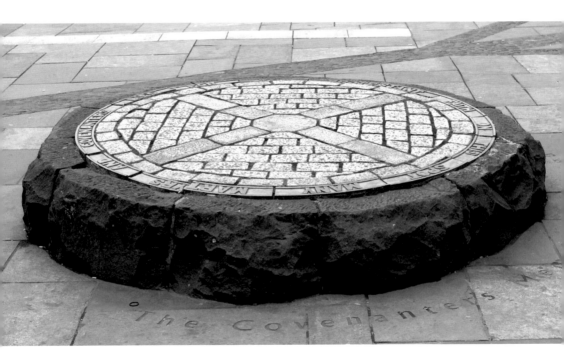

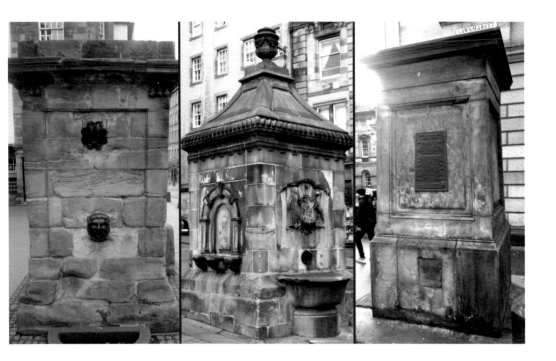

Sinclair as surveyor; Peter Brauss, a German engineer who made the lead pipe-work; and Robert Mylne, the king's master mason who built the well-heads. Mylne's Bow Foot Well in the Grassmarket is the finest. Others are at Parliament Square, the High Street at Old Assembly Close, and near John Knox House.

The gravitational water supply was piped from Comiston Springs on the south side of the city and flowed to a large cistern at the head of the West Bow, from where it was piped through elm-wood pipes to the wellheads in the Old Town. Previously water was sourced from springs and delivered to houses by water caddies.

Wardrop's Court Dragons

The four carved ornamental wooden dragon brackets at Wardrop's Court have a direct connection with Sir Patrick Geddes, the influential town planner, who, in the 1890s, commissioned the building above the close to a design by Stewart Henbest Capper. The dragons were added around 1911 – two of them were carved by J. S. Gibson and the other two by Geddes' teenage son, Arthur, under the guidance of the sculptor Alec Miller. The dragon motifs reflect Geddes' interest in Celtic mythology. The dragons were beautifully restored in 2013.

The Zannah Stephen Memorial, James Court

A small sandstone memorial with bronze detailing – a parakeet swinging on a garden trug basket and bronze leaves. The stone is inscribed: 'Keep Your Face Toward The Sun & The Shadows Will Fall Behind You. In Memory of Susannah Alice Stephen. 1960–97.' It was designed by Frances Pelley and installed in 2000. The memorial commemorates Susannah Alice (Zannah) Stephen, who was born in 1960 in Renfrewshire, trained as a landscape architect in Edinburgh and helped to found the Scottish Society of Garden Designers. She died in a diving accident in the Galápagos Islands in 1997. The memorial was erected by her friends to commemorate her life.

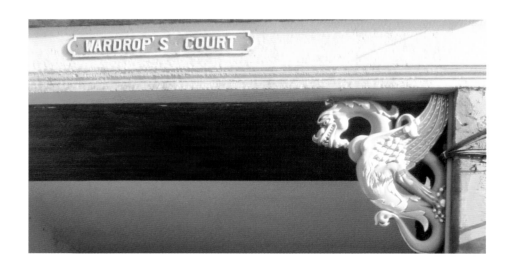

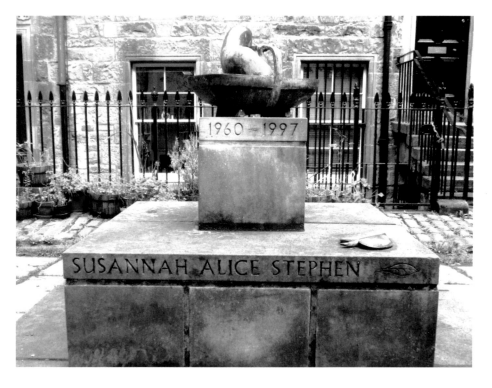

John Knox Statue, New College Quadrangle, Mound Place

Bronze statue of John Knox, the Scottish theologian who led the Scottish Protestant Reformation, in the New College quadrangle. The statue by John Hutchison (1832–1910) depicts Knox in gown and hat preaching with a Bible in his left hand and his right arm raised towards heaven. The inscription reads: 'John Knox 1514–72. Erected by Scotsmen Who are Mindful of the Benefits Conferred by John Knox on Their Native Land. 1896.'

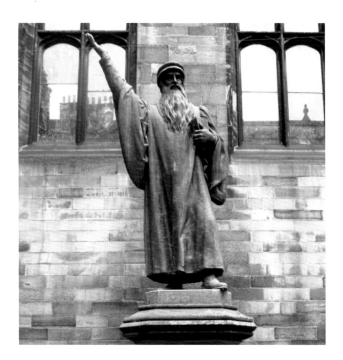

The Black Watch Monument, Bank Street/ The Mound

A striking 11-foot-high (3.3 metres) bronze statue of a Black Watch soldier on a 17-foot-high (5 metres) pedestal. The soldier is shown in full dress uniform holding a rifle and looking towards the castle. On the front, on a square polished granite base is the Black Watch crest *'Am Freiceadan Dubh'* above a bas-relief of soldiers at the Battle of Magersfontain. It was designed by sculptor William Birnie Rhind.

The memorial commemorates General Wauchope and the men of the Black Watch regiment who fell in the South African War, 1899–1902. It was commissioned by the regiment on a site given by the Bank of Scotland in 1906. *The Scotsman*, on 25 May 1910, reported that there would be no unveiling ceremony for the monument 'owing to the lamented death of King Edward VII'.

Inscriptions on a square base plinth read:

> To the memory of Officers, Non-Commissioned Officers and Men of the Black Watch who fell in the South African War 1899–1902. The men who died from disease. The men who died in action or from wounds.

David Hume Statue, High Street

This seated bronze statue of David Hume on a sandstone plinth was sculpted by Alexander 'Sandy' Stoddart, the Queen's Sculptor in Ordinary in Scotland. It includes a number of references to Hume's humanist principles – the dogs' heads on the back of his chair referring to Diogenes' praising of the virtue of dogs over man.

The statue was commissioned by the Saltire Society and was unveiled on 30 November 1997, St Andrew's Day, by Professor Sir Stewart Sutherland, Principal and Vice Chancellor of the University of Edinburgh.

David Hume (1711–76) was perhaps the most influential figure of the Scottish

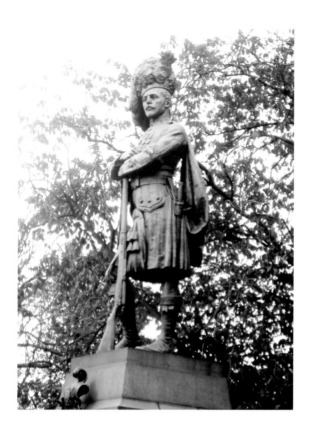

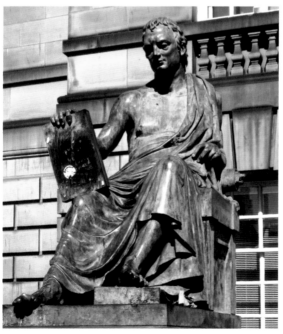

Enlightenment – philosopher, historian, economist and diplomat. His works include *A Treatise of Human Nature*, *An Enquiry Concerning Human Understanding*, and *An Enquiry Concerning the Principles of Morals*. He died in 1776 and was buried in Calton Old Burial Ground in the Hume Mausoleum.

The big toe of Hume's right foot projects out over the plinth and it has become a superstition that rubbing it will bring good luck – as a result it has become shinier than the rest of the statue. There is a certain irony in this, given that Hume believed that logical thought is an answer to superstitious beliefs.

Memorial to Walter Francis, 5th Duke Of Buccleuch and 7th Duke Of Queensberry, West Parliament Square, High Street

A 32-foot-high (9.7 metres) Gothic-style pedestal surmounted by a bronze figure of the Duke of Buccleuch dressed in the robes of the Order of the Garter.

The statue was erected to commemorate the life of Walter Francis Montague Douglas Scott, 5th Duke of Buccleuch and 7th Duke of Queensberry (1806–84). He held appointments as Lord Privy Seal, Lord President of the Council, and Lord Lieutenant of Midlothian and of Roxburgh, and was responsible for the building of Granton Harbour in 1835. The memorial was officially unveiled on 7 February 1888, by the Earl of Stair. It cost around £6,700, paid for by around 1,200 subscribers.

Sir Joseph Edgar Boehm (1834–90) was responsible for the main statue and the hexagonal sandstone plinth was designed by Sir Robert Rowand Anderson.

The stag-hunting scene around the top reflects the derivation of the family name from a buck being hunted in a 'cleuch' (a hollow) in the Borders hills. The plinth is decorated with allegorical figures and incidents from the Buccleuch family history.

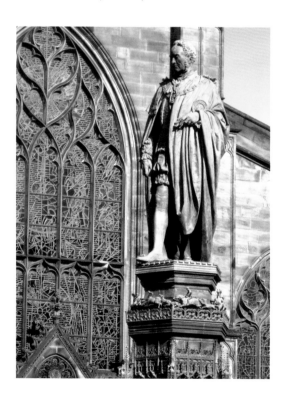

The lower panels by Clark Stanton depict incidents from the history of the Scott-Buccleuch family:

- The death of Sir Walter Scott at Hamilton Hall in 1402.
- The burning in 1548 of Catslack Tower with Lady Buccleuch inside.
- The attempted rescue of James V from the Earl of Angus.
- The burning of Branxholm Tower in 1534.
- The pursuit by Buccleuch of English cattle reivers.
- The appeasement of Queen Elizabeth by the Laird for the rescue of Kinmont Willie from Carlisle Castle in 1596.

The upper reliefs show incidents from the life of the fifth duke:

- The reception of Queen Victoria at Dalkeith in 1842.
- The inception of Granton Harbour (built on Buccleuch land).
- The anniversary dinner given by his tenants in 1877.
- His installation as Chacellor of Glasgow University.
- The duke as the Colonel of Militia of his regiment.

Heart Of Midlothian, West Parliament Square, High Street

The heart-shaped setts in the cobbles mark the entrance to the Old Tolbooth, named the Heart Of Midlothian after the novel by Sir Walter Scott. The Tolbooth served as a law court, a tax-office and later a prison. Local tradition is to spit on the heart to bring good luck.

Charles II Statue, Parliament Square

The imposing lead equestrian statue of King Charles II (1630–85) is the oldest statue in Edinburgh, and one of the oldest lead statues in Britain. It depicts the king in Roman military dress, sitting astride a horse holding a baton, a symbol of Imperial authority, in his right hand and wearing a victor's laurel wreath. Robert Louis Stevenson

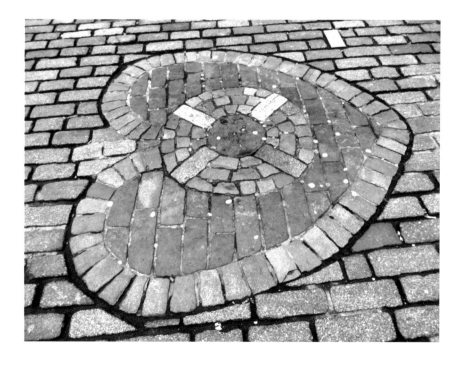

caricatured the statue as 'a bandy-legged and garlanded Charles Second, astride a tun-bellied charger'.

The statue was presented to Edinburgh by James Smith, the Surveyor of the King's Works, in 1685 as a tribute to the king. Recent evidence attributes the statue to the workshop of the famous Dutch sculptor and master carver Grinling Gibbons.

Stone of Remembrance – Edinburgh War Memorial, High Street

The war memorial under the arches of the City Chambers was erected by the 'Edinburgh Citizens Cenotaph Committee', which raised funds by public subscription to commemorate the people of Edinburgh who lost their lives in the First Wold War. The simple oblong granite block was designed on similar lines to memorials designed by Sir Edward Lutyens for British war cemeteries. It is inscribed with gold lettering: 'Their Name Liveth For Evermore, 1914–18 and 1939–45.'

It was unveiled on Armistice Day, 11 November 1927, by a party led by Prince Henry (Duke of Gloucester, the son of George V) and was accepted by Lord Provost Sir Alexander Stevenson on behalf of the citizens of Edinburgh.

James Braidwood Statue, East Parliament Square

James Braidwood (1800–61) established the world's first municipal fire service in Edinburgh in 1824. Braidwood trained as a builder and surveyor before being appointed Edinburgh's master of fire engines at the age of twenty-four, just before the Great Fire of Edinburgh. He introduced methods of fire-fighting that are still used today and is credited with the development of the modern municipal fire service. He was later appointed as the first director of what was to become the London Fire Brigade. Braidwood died fighting the Tooley Street fire at Cotton's Wharf in London on 22 June 1861, when he was crushed by a falling wall.

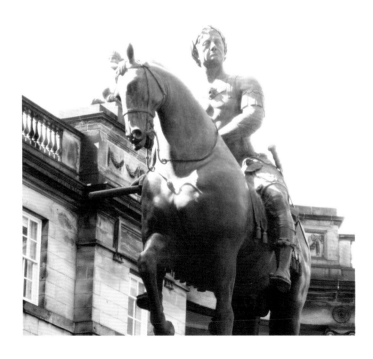

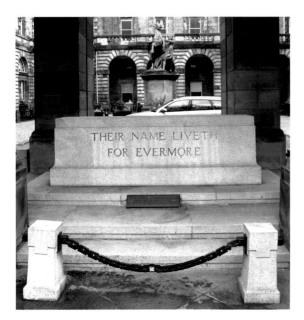
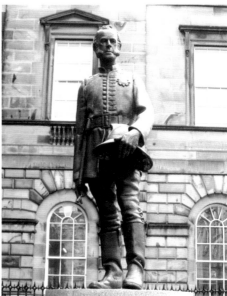

The statue is by by Glasgow sculptor Kenneth Mackay, and was unveiled by Professor Sir Timothy O'Shea, Principal of Edinburgh University, on 5 September 2008. It was instigated by Frank Rushbrook, a former Fire-Master in Edinburgh.

The bronze plaque on the granite pedestal reads: '1800–61. Father of the British Fire Service.' This statue is dedicated to the memory of James Braidwood, a pioneer of the scientific approach to fire-fighting. It also recognises the courage and sacrifice of fire-fighters, not only in Lothian & Borders Fire and Rescue Service, but all over the world.

The Edinburgh Mercat Cross, High Street

Mercat (Market) crosses were a symbol of a town's right to hold a market – an important privilege. Edinburgh's mercat cross was the focal point for trade, the place where public proclamations were made and executions held.

The cross, which then stood about 45 feet (14 metres) from the east end of St Giles, is first mentioned in a charter of 1365. In 1617, it was moved a short distance down the High Street and in 1756 it was demolished and partly re-erected at Drum House in Gilmerton. In 1866 the pieces of the cross from Drum House were reassembled beside the north door of St Giles.

In 1885, William E. Gladstone, Prime Minister and M.P. for Midlothian, commissioned Sydney Mitchell to design a new structure – an octagonal platform with Ionic columns, carved and coloured coats-of-arms, and a central stone shaft surmounted by a unicorn, which was sculpted by John Rhind from a design by James Drummond and added in 1869.

Gladstone had a Latin inscription placed above the doorway which translates:

THANKS TO GOD. This ancient monument, the Cross of Edinburgh, which of old was set apart for public ceremonies, but, having been utterly destroyed by a misguided hand, A.D. MDCCLVI, was avenged as well as lamented, in song alike noble and manful, by that great man Walter Scott, has now by favour of the Magistrates of the City, been restored by William Ewart Gladstone, who claims through both parents, a purely Scottish descent. 24th November 1885.

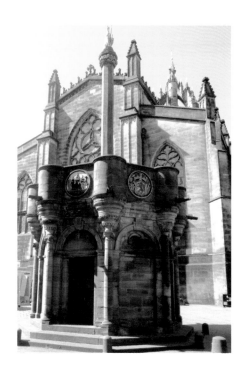

There are eight coats of arms (starting above the door and going right) representing: the Royal Arms of Scotland, the Arms of Edinburgh, the Royal Arms of the United Kingdom within Scotland, the Irish, Leith, the Burgh of Canongate, the University of Edinburgh and the Royal Arms of England.

Adam Smith Statue, High Street

The bronze statue of Adam Smith in academic robes was sculpted by Alexander Stoddart and was unveiled on 4 July 2008 by Nobel laureate economist Vernon Smith. Kirkcaldy born, Adam Smith (1723–90), is best known for two classic works: *The Theory of Moral Sentiments* (1759) and his influential masterpiece *An Enquiry into the Nature and Causes of the Wealth of Nations* (1776). The first established Smith as a moral philosopher and the second as the father of modern economics. In 2007, an image of Smith appeared on Bank of England £20 notes, making him the first Scotsman to feature on an English banknote. The statue includes a reference to the Smith's famous 'Invisible Hand' of the free market – concealed under his academic gown.

Alexander and Bucephalus Statue, City Chambers Courtyard

The statue depicts a young Alexander the Great taming the reputedly uncontrollable horse Bucephalus (bull-headed) by turning it towards the sun as he realised the horse was afraid of its own shadow.

The sculpture is by Sir John Steell, who copied Alexander's head from a statue in a Florentine gallery. The plinth is inscribed on the front: 'Alexander and Bucephalus' and on each side: 'Presented to the City by the Subscribers. 1884 and Modelled 1832. Cast in Bronze 1883.

The statue was originally unveiled on the west-side of St Andrews Square on 19 April 1884. It was re-sited to the City Chambers courtyard in 1916, to provide space for the

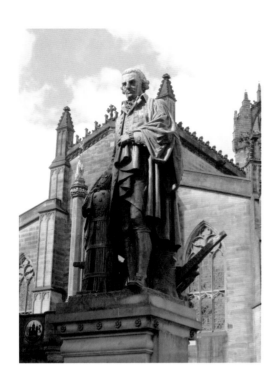

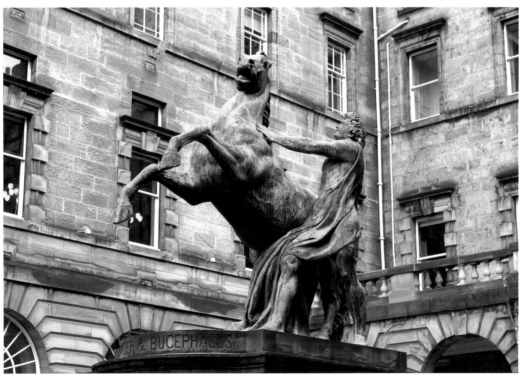

Gladstone Memorial in St Andrew Square – which itself was subsequently re-sited to Coates Crescent.

Steell was first commissioned to sculpt the statue in 1832 and it lay unfinished for fifty-years before finally being cast in bronze. This is the basis of the legend that Steell finished the horse with pig's ears out of frustration over money or the delay in finding a site for his work. It seems that there may be some truth in this, following the discovery of an early model of the statue which shows that Steell modified the design of the ears between the original sculpture and the casting.

Body and Soul/Pears and Nuts, Hunter Square
Body and Soul is the name of the stone water feature by Peter Randall-Page, who created the sculpture in 1996 from Black Zimbabwe granite.

Pears and Nuts is a series of square cast bronze baskets containing fruit and nuts on black polished granite columns by Ian Hamilton Finlay.

King's Own Scottish Borderers Memorial, North Bridge
This sandstone statuary group of four soldiers on a stone pedestal base with laurel leaves on three sides was designed and sculpted by William Birnie Rhind RSA. One figure is standing in a greatcoat holding binoculars, with three other soldiers, one wounded private and two in readiness with rifles, crouching at his feet.

The statue was unveiled by Lieutenant General Keach, VC, Commanding Officer of Forces in Scotland, and built by private subscription under the supervision of the KOSB Memorial Committee. The unveiling ceremony took place on 4 October 1906. The memorial commemorates men of the King's Own Scottish Borderers – the Edinburgh Regiment – who gave their lives during the regiment's foreign campaigns between 1878 and 1902.

The bronze plaque below reads:

In Memory of Officers, Non-Commissioned Officers and Men, Who Whilst Serving With the King's Own Scottish Borderers (The Edinburgh Regiment), Gave Their Lives for Their Country During The Following Campaigns, Afghanistan 1878–1900, Egypt 1888–89, Chin Lushai 1889–90, Chitral 1895, Tirah 1897–98, South Africa 1900–02.

Sir Patrick Geddes, Sandeman House Garden, Trunk's Close
The bust of Sir Patrick Geddes (1854–1932) by the artist Kenny Hunter was unveiled in the

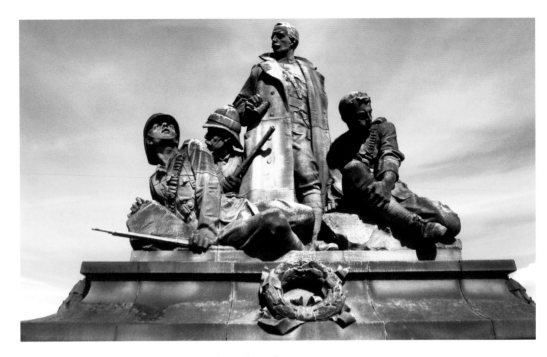

King's Own Scottish Borderers Memorial, North Bridge.

landscaped garden at Sandeman House on 28 September, 2012. The plinth is in the form of a stack of beehives – an allusion to Geddes' training as a biologist and the dissemination of his ideas. Geddes made his mark in many areas of study, but is most well known as a pioneering town planner. He worked in many parts of the world and was influential in nineteenth-century improvement work in Edinburgh's Old Town.

Robert Fergusson Statue, Canongate

Robert Fergusson (1750–74) was born in Edinburgh's Old Town. He was a prolific poet in Old Scots and sadly died in the Bedlam asylum at the age of twenty-four. He was much admired by Robert Burns, who paid for a headstone for Fergusson's previously unmarked grave in the nearby Canongate Kirkyard.

The statue was by commissioned by the Friends of Robert Fergusson and sculpted by Robert Annand. It shows Fergusson as a vigorous young man about town. Three winning plaster model entries for a design competition were exhibited across the city and the public voted for the best one. It was unveiled on 17 October 2004 by Lady Provost Lesley Hinds.

The Canongate Mercat Cross, Canongate Churchyard

The Canongate was a separate burgh from Edinburgh until 1856. The Canongate Mercat Cross was a symbol of this separate identity, marking the site of the burgh market. It is decorated with the Canongate burgh arms – the head of a stag with a cross between its antlers.

In the sixteenth century, the cross stood in the middle of the street. It was moved close to the Tolbooth in 1737, re-sited on the pavement in front of the Canongate Churchyard in 1888 and to its present location within the churchyard in 1953. Very little remains of the original cross due to restoration and repairs over the centuries.

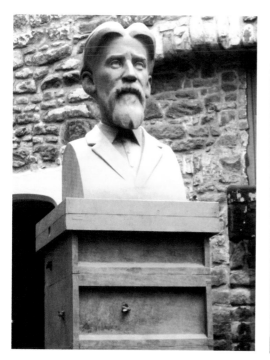
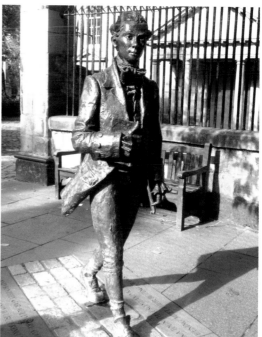

Everyman Sculpture, Waverley Court, East Market Street

The *Everyman* sculpture, at the entrance to Edinburgh Council's headquarter building at Waverley Court, depicts a a red-haired man dressed in a white shirt and black trousers standing on top of a colourful scaffold tower. The statue, by German artist Stephan Balkenhol, was the result of a design competition. It was unveiled in 2007 and was intended to represent the council's 'Edinburgh – Inspiring Capital' brand.

Edward VII Statue, Palace of Holyroodhouse

The statue depicts King Edward VII (1841–1910) in the robes of a Knight of the Thistle. The statue was designed by Henry Snell Gamley and unveiled by King George V on 10 October 1922. The main inscription reads:

> In Memory of Edward King of Great Britain and Emperor of India. 1901–10. His Scottish Subjects Have Erected This Memorial in Grateful and Loyal Remembrance.

Palace Yard Fountain, Palace of Holyroodhouse

The large and ornate fountain at the centre of the palace forecourt was erected as part of work to the palace grounds in the 1850s. It is a replica of a fountain at Linlithgow Palace which dates to 1628. It was carved by John Thomas, a well-known sculptor of the time. The intricate carvings depict events from the history of the Scottish royal family and aristocratic pastimes, such as falconry and music.

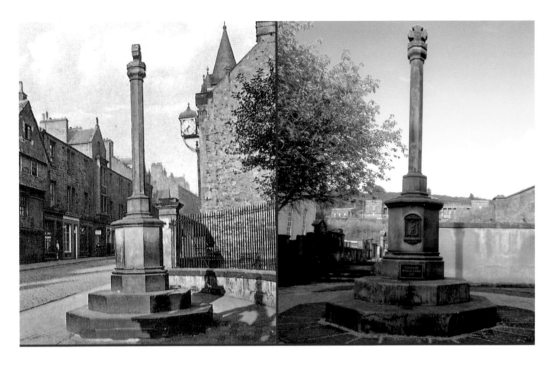

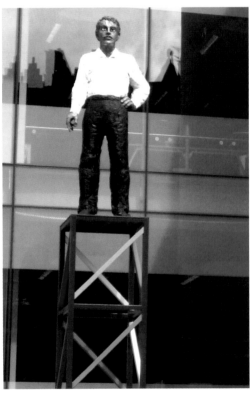

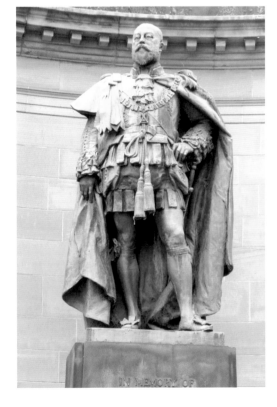

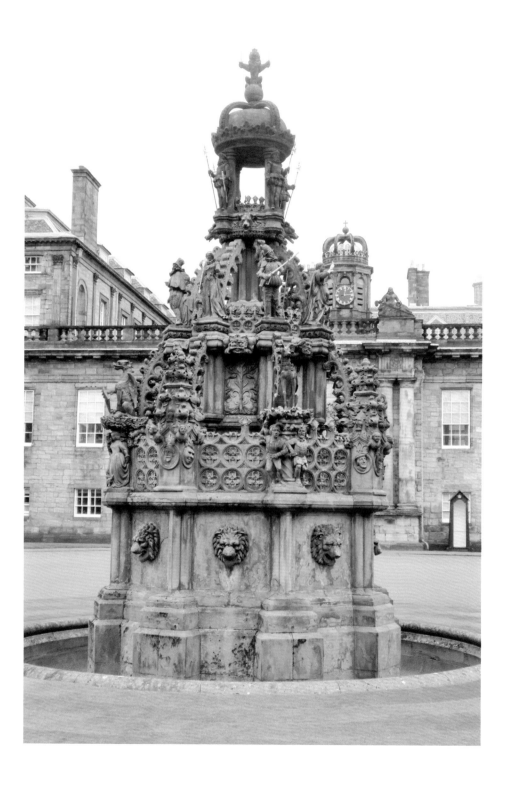

Edinburgh Castle Esplanade

The esplanade forms the approach and forecourt to Edinburgh Castle. It was established as a parade ground in the mid-eighteenth century and hosts a range of military related monuments.

The Scottish Horse Memorial

The Scottish Horse Memorial is a pink granite Celtic cross decorated with intricate carved scrollwork, a sword and a lion rampant on a shield. The memorial includes the regimental motto *Nemo Me Impune Lacessit* (No one attacks me with impunity – Wha daur meddle wi' me), which is also the motto of Scotland. It stands on a rock-cut granite plinth with a bronze panel listing soldiers of the regiment, including four Zulu scouts, killed in action or by disease.

 The memorial dates from 1905 and commemorates service by the Scottish Horse regiment in the South African War, 1901–02. The Scottish Horse was raised in South Africa as a mounted infantry regiment and disbanded at Edinburgh Castle on 3 September 1902.

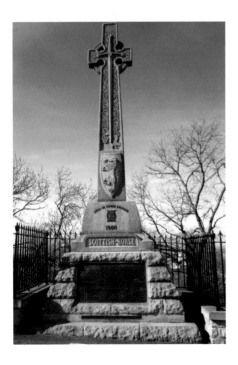

Ensign Ewart Memorial

Kilmarnock-born Ensign Charles Ewart (1769–1846) was a Scottish soldier of the Royal North British Dragoons (the Scots Greys), famed for capturing the regimental eagle standard of the French 45th Regiment (the French Invincibles) at the Battle of Waterloo in 1815. Ewart was an expert swordsman and is described as being of 'Herculean strength'. He was hailed as a hero on his return and left the army in 1821. He lived in Salford, where he was buried in 1846. His grave was covered over and forgotten until the 1930s, when it was exhumed and his remains were reburied on the esplanade. The simple block of Swedish granite by William Kininmonth was erected to his memory in April 1938.

Duke of York Statue

A bronze pedestrian statue of Frederick, Duke of York and Albany (1763–1827), holding his field marshal's baton in the robes of a Knight of the Garter by John Greenshields. The inscription reads: 'Field Marshal His Royal Highness Frederick Duke of York and Albany, K.G. Commander in Chief of the British Army MDCCCXXVII.'

Prince Frederick was the second son of King George III. He was given high rank in the British Army from a relatively young age. The army was succesful in a number of campaigns under his command. However, it is for his military failures that he is remembered in the rhyme 'The Grand Old Duke of York':

> The grand old Duke of York,
> He had ten thousand men.
> He marched them up to the top of the hill
> And he marched them down again.
> And when they were up, they were up.
> And when they were down, they were down.
> And when they were only halfway up,
> They were neither up nor down.

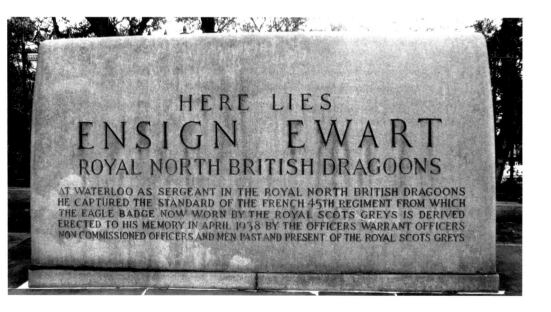

Colonel Mackenzie Monument

A finely carved dark stone Celtic cross decorated with foliage scrollwork, a sword and mythical animals on a rubble plinth. The cross dates from 1875 and was sculpted by Sir John Steell. The cross commemorates Colonel Douglas Mackenzie, CB (1811–73). The inscription on a red granite plaque on the plinth reads:

> In Memory of Colonel Kenneth Douglas Mackenzie, C.B. Who Served For Forty Two Years in the 92nd Highlanders and on the Staff of the Army in All Parts of the World. He Saw Much Service In the Field and Deserved Well of His Country, Both in War and in Peace. Active, Frank, and Loyal, He Won the Confidence of His Superiors, the Respect of Those Under Him and the Love of All Who Knew Him. Born at Dundee 1st February 1811. Died On Duty at Dartmoor 24th August 1873. His Motto Through Life Being 'Godliness With Contentment Is Great Gain!' This Memorial Is Erected In Affectionate Remembrance by Many of His Friends.

72nd Duke of Albany's Own Highlanders Monument

A polished pink Peterhead granite obelisk with a bronze crown over the number 72. The 72nd Duke of Albany's Own Highlanders Infantry Regiment of the Line was raised in the late eighteenth century in Scotland for service against the French. The obelisk is a memorial to the soldiers who were killed or died of wounds or disease in the Afghan campaign, 1877–80.

The base of the obelisk has the following inscription along with the names of fallen soldiers: 'In Memory of the Officers Non Commissioned Officers and Men of the 72nd

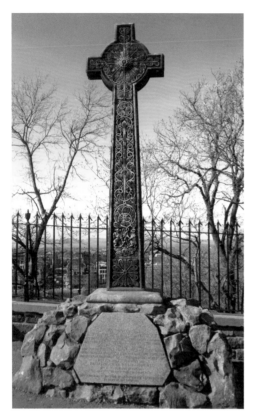
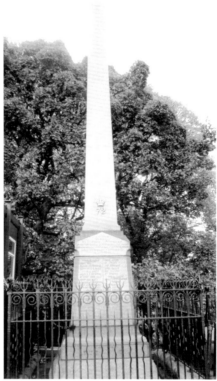

Duke of Albany's Own Highlanders Who Were Killed In Action or Died of Wounds or Disease During the Campaigns in Affghanistan (Sic) in 1878–79. Erected by the Officers and Men Now Serving and Who Have Served in the Regiment.'

78th Highlanders Memorial
A 27-foot-high (8 metres) stone Celtic cross by Robert Rowand Anderson, carved with Celtic knotwork, a stag's head, and an Indian elephant to commemorate officers and men who fell in the Indian Mutiny (1857–58). The memorial was unveiled on 16 April 1862 in the presence of a large company of officers, soldiers and spectators.

The main inscription reads: 'Sacred to the Memory of the Officers Non-Commissioned Officers and Private Soldiers of the LXXVIII Highland Regiment Who Fell in the Suppression of the Mutiny of the Native Army of India in the Years MDCCCLVII and MDCCCLVIII: This Memorial is Erected as a Tribute of Respect by Their Surviving Brother Officers and Comrades and by Many Officers Who Formerly Belonged to the Regiment. Anno Domini MDCCCLXI. '

Bruce and Wallace
The life-size bronze statues on either side of the castle drawbridge entrance are of the Scottish heroes Robert the Bruce (left) and William Wallace (right).

In 1827, Captain Hugh Reid, an exiled Anglo-Scot, bequeathed £2,000 to erect memorials to Wallace and Bruce in the city. However, there was a long, complicated

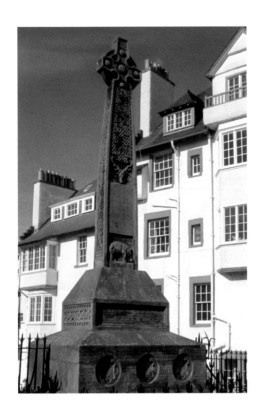

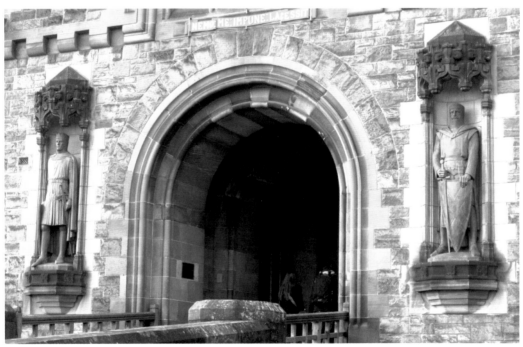

legal wrangle and the statues were eventually erected in 1929 – nearly 100 years later. A nearby plaque states: 'Erected by the Corporation of Edinburgh under Captain Hugh Reid's bequest. Unveiled 28th May 1929. The Right Hon. Sir Alexander Watson, Lord Provost.'

Robert the Bruce (1274–1329) was King of Scotland (1306–29) and was one of the most famous warriors of his generation, eventually leading Scotland during the Wars of Scottish Independence against England. He claimed the Scottish throne as a great-great-great-great grandson of David I of Scotland. The statue is engraved, 'Thomas Clapperton R.S.A. 1929 – Sculptor.'

Sir William Wallace (1274–1305) was a knight and Scottish patriot who led the resistance to the English occupation of Scotland during the Wars of Scottish Independence. The statue is engraved: 'Alexander Carrick R.S.A. 1929 – sculptor.'

Witches Well

This art nouveau-style well was erected in 1912, at the suggestion of Professor Patrick Geddes. It commemorates the hundreds of people persecuted for witchcraft.

In the latter part of the sixteenth century the country was preoccupied with superstition and the need to expose those suspected of 'confederating with the Devil'. Castlehill was where no fewer than 300 people, mainly women, are believed to have been executed for witchcraft, more than any other place in Scotland.

The design is inspired by mythology – Aesculapius, the God of Medicine, is represented by a serpent and Hygeia, the Goddess of Health, is depicted along with the shrivelled face of a woman who has become a witch and a stem of foxglove. The panel on the trough has symbols representing the 'cleansing fire', the 'hands of healing' and the 'evil eye'.

The plaque beside the well reads:

This Fountain, designed by John Duncan, R.S.A. is near the site on which many witches were burned at the stake. The wicked head and serene head signify that some used their exceptional knowledge for evil purposes while others were misunderstood and wished their kind nothing but good. The serpent has the dual significance of evil and wisdom. The Foxglove spray further emphasises the dual purpose of many common objects.

Statue of Earl Haig, Edinburgh Castle

This equestrian bronze statue on a granite plinth depicts the uniformed Field Marshall Earl Douglas Haig (1861–1928). It was designed by George Wade, whose name is engraved on the rear left foot of the horse.

A small metal plaque is inscribed:

EARL HAIG: This statue was presented to the City of Edinburgh by Sir Dhumjibhoy Bomanji of Bombay in admiration of the services rendered to the British Empire by the Field Marshal.

It was unveiled by the Lord Provost on 28 September 1923.

Haig was born in Edinburgh's Charlotte Square in 1861. He commanded the British Army in France for most of the First World War, and his name has become associated with the carnage of the conflict. In 1921, Earl Haig established the Royal British Legion and the Earl Haig Fund to assist ex-servicemen.

The statue was moved from the Esplanade to Hospital Square within the Castle in 2009, to more easily accommodate the grandstands for the Tattoo.

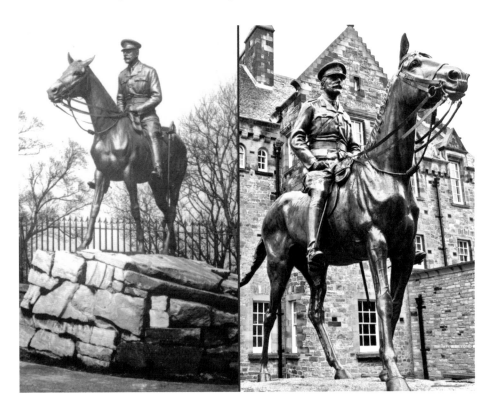

East Princes Street Gardens

David Livingstone Statue

This pedestrian bronze statue shows David Livingstone (1813–73), the Scottish missionary and explorer, wearing a cloak and haversack, having cast off a lion skin – an allusion to him having survived a lion attack. He is holding a walking stick and Bible, with a pistol and compass at his waist. The statue was cast by R. Masefield & Co., brassfounders of London. It was sculpted by Amelia Robertson Hill (1820 – 1904), one of the few women sculptors in nineteenth-century Edinburgh, who also did three character statues on the nearby Scott Monument. She was a gifted artist, but has been overshadowed by her more famous artist brothers Sir Noel Paton and Hugh Waller Paton, and her husband – pioneering photographer David Octavius Hill. The statue was commissioned by the

Livingstone Memorial Committee and a site was granted in East Princes Street Gardens in 1875. It was unveiled on 15 August 1876 and handed over to the Lord Provost and Town Council.

David Livingstone was born on 19 March 1813 in Blantyre, Lanarkshire, and worked in a cotton factory. At the age of twenty, he became a devout Christian and in 1840 was ordained as a missionary. He was sent to South Africa on missionary work and became a renowned explorer. In 1856, he was awarded the gold medal of the Royal Geographic Society and other honours for his discoveries. He returned to Africa in 1858 and discovered Lake Nyasa. He was also prominent in the campaign to abolish slavery. He died in 1873, while searching for the source of the Nile. His body was returned to England and was interred at Westminster Abbey.

The Sir Walter Scott Monument

The most prominent landmark in Edinburgh is also the biggest monument to any writer in the world – it commemorates Sir Walter Scott (1771–1832). Scott was a best-selling novelist who invented the Gothic historical novel and created the idea of Scottish Romanticism. His Waverley novels excited critical acclaim around the world. He was a prominent society figure who rediscovered the hidden royal Scottish regalia in Edinburgh Castle and orchestrated the visit by King George IV to Scotland in 1822 – the first British monarch to visit Scotland since Charles II in 1650 – and persuaded the king and dignitaries to wear the previously banned tartan.

The monument is made from Binny sandstone from West Lothian, designed in Gothic

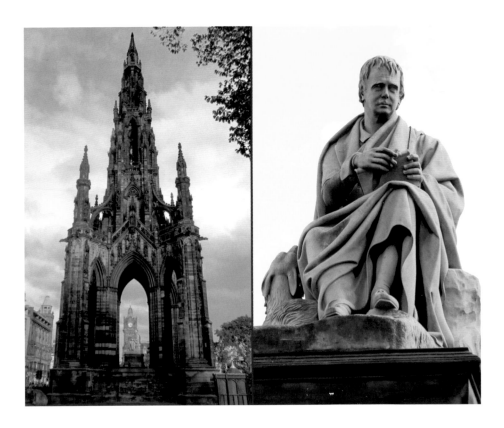

style with four arched buttresses supporting a central tower. It stands just over 200 feet (61 m) high, took six years to build and has 287 spiral steps to the top. Within niches there are sixty-four character statues from Scott's novels, carved by many well-known sculptors. On the first level, a museum room with large stained glass panels by James Ballantine has emblems of St Andrew and St Giles, fine decorative carved oak and gilded portrait heads of Scottish historical characters.

Following Scott's death in 1832 money was raised by public subscription to build a memorial. A competition was arranged in 1838 for a design for the monument. The final winning design was by George Meikle Kemp (1795–1844). Kemp was a carpenter from Midlothian who had drawn Gothic architecture since his youth, was much inspired by Melrose Abbey, and won the design competition over many established architects. Kemp drowned in the Union Canal before the monument was finished and the final works were supervised by his brother-in-law, William Bonnar.

The foundation stone was laid on 15 August 1840 and the inauguration ceremony was on the same date (Scott's birthday) in 1846. Both occasions were marked with much pomp and ceremony – processions of a mounted military band, masonic lodges, town councillors and magistrates of Edinburgh, Canongate, Leith and Portsburgh.

Sir John Steell (1804–91) was the sculptor of the double-life size Italian Carrara marble statue of Scott with his deerhound, Maida, on the central platform. A bronze copy of the Scott statue was bought by expatriate Scots in America and unveiled in 1872 in New York's Central Park.

In 1997–98, a comprehensive restoration to replace deteriorated masonry was undertaken using stone from the specially re-opened Binny stone quarry in West Lothian. The original stone contained shale oil which blackened the stone. Smoke from 'Auld Reekie' and the nearby railway line also contributed to this. The monument was not cleaned as the removal of the grime would have damaged the stone.

Adam Black Statue

This bronze statue on a sandstone plinth depicts Adam Black (1784–1874) in his ermine robes as Lord Provost of Edinburgh. It was designed by John Hutchison RSA (1833–1910) and unveiled on 3 November 1877. It was commissioned by the Black Memorial Fund, gifted to the city by Lord Moncrieff on behalf of the Memorial Fund and accepted by Lord Provost Falshaw on behalf of the Town Council. The Town Council granted the site in Princes Street Gardens and provided £50 towards the costs.

Adam Black was an eminent publisher and liberal politician. He was one of the main booksellers in the city and founded the A. & C. Black publishing company. The company acquired the lucrative publishing rights for the *Encyclopaedia Britannica*, the works of Thomas De Quincey and Sir Walter Scott's Waverley novels. He became an Edinburgh town councillor in 1832, was twice Lord Provost and represented the city in Parliament from 1856 to 1865.

John Wilson Statue

A bronze pedestrian statue depicting Professor John Wilson, 'Christopher North' (1785–54), with flowing locks and beard, his right hand clutching a cloak and quill with his left hand resting on a half-open manuscript.

The Wilson Statue Committee was formed after his death and commissioned the work from sculptor Sir John Steell. The statue was unveiled on 25 March 1865 – the same day as the nearby Allan Ramsay marble statue.

Wilson was born to a wealthy family near Paisley, and studied at Glasgow and Oxford universities. Qualified in law, he enrolled as an advocate in 1814, but his main ambition was to write. He found his niche as a reviewer and essayist for *Blackwood's Magazine* under the pseudonym of Christopher North.

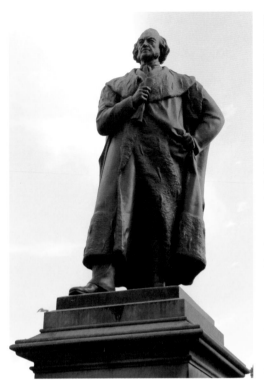 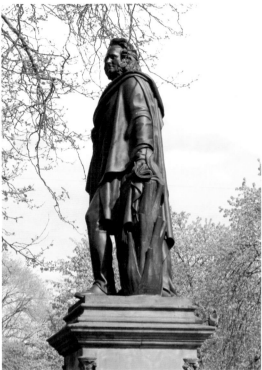

In 1819, he was appointed Professor of Moral Philosophy at Edinburgh University, although his appointment caused some controversy. He was an influential thinker of his day, although his anti-reform views provoked opposition.

The International Brigade Memorial
A simple rough-hewn stone, erected by the Friends of the International Brigade in the late 1980s to commemorate Lothian Volunteers who joined the International Brigade in the Spanish Civil War in the war against fascism. The inscriptions read:

To honour the memory of those who went from the
Lothians and Fife to serve in the war in Spain 1936 – 1939

Not a fanfare of trumpets
Nor even the skirl o' the pipes
Not for the off'r of a shilling
Nor to see their names up in light
Their call was a cry of anguish
From the hearts of the people of Spain
Some paid with their lives it is true
Their sacrifice was not in vain

Erected by the International Brigade Association

Relief Model of Edinburgh

On the Mound piazza overlooking East Princes Street Gardens, this bronze three-dimensional topographical model of the city centre was intended to act as a guide for blind people. It was made by artist David Westby and gifted by Marks & Spencers in 1984.

World Heritage Stone

An inscribed paving stone beside the Relief Model commemorates the designation of the Edinburgh Old and New Towns as a World Heritage Site by Unesco in 1995. The stone is decorated with the Unesco World Heritage emblem and is the largest example of inscribed Caithness stone in the world.

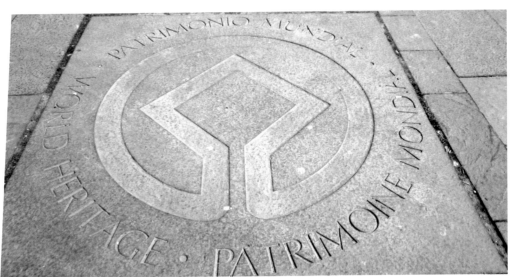

West Princes Street Gardens

Allan Ramsay Statue

The 10-foot-high (3 metres) statue of Allan Ramsay was sculpted by Sir John Steell from an eighteen-ton marble block. It stands on an ornate sandstone plinth, which is decorated with medallions of Ramsay's family.

Ramsay (1685–1758) is depicted in eighteenth-century costume holding a book in his left hand and a pencil in his right. He is shown wearing a silk night-cap, rather than a wig – an allusion to the fact he trained as a wig-maker as a young man. The features are based on a portrait by the poet's son, Allan Ramsay (1713–84), the prominent portrait-painter.

The monument was commissioned and funded by Lord Murray of Henderland, the great-nephew of Allan Ramsay. It was unveiled by Sir John McNeil on 25 March 1865 at

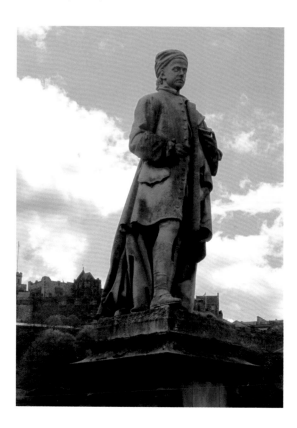

a dual ceremony to inaugurate the Professor John Wilson statue on the other side of the Royal Academy.

Allan Ramsay is credited with opening the first circulating library, in a shop on the Royal Mile in 1725. He was involved in the revival of Scots vernacular poetry and is best remembered for his five-part work, *The Gentle Shepherd.* 'Honest Allan', as he was known, opened a theatre in Ednburgh in 1736, which was soon closed down by the magistrates.

Ramsay built Ramsay Lodge, known as the 'Goose-pie' from its unusual octagonal shape, in what is now Ramsay Garden at the top of the Royal Mile. It was originally intended that the statue would be located on a terrace at the Lodge. However, the terrace collapsed and the new location in Princes Street Gardens was found. Ramsay Lodge was later incorporated into the Ramsay Garden development.

The mechanism for the adjoining floral clock is housed in the pedestal of the statue. The Edinburgh floral clock was originally planted in 1903 and was the first in the world. It was the idea of James McHattie, City Superintendent of Parks, and James Ritchie, the Edinburgh clockmaker. The first clock only had an hour hand – a minute hand was added in 1904 and a cuckoo in 1905 – and the original clock mechanism was salvaged from Elie parish church.

Thomas Guthrie Monument

This pedestrian Portland stone statue depicts the robed standing figure of Thomas Guthrie (1803–73), the philanthropist, preacher and reformer, with one hand on the shoulder of a 'ragged boy' and the other holding a Bible.

The statue was sculpted by Frederick W. Pomeroy (1856–1924), at the instigation of Mr A. Guthrie of Liverpool. Lord Balfour of Burleigh unveiled the statue on 3 October 1910,

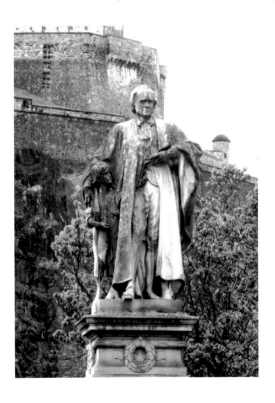

and described Guthrie as 'a great orator, a practical philanthropist and a very apostle of social reform'.

Guthrie was born in Brechin and educated at Edinburgh University. He was minister at Greyfriars Kirk, but later led the breakaway from the Church of Scotland to establish Free St John's Church on Castlehill. He was a commanding speaker and the most popular preacher in Scotland in his day. He became moderator of the Free Church assembly in 1862, published *A Plea for Ragged Schools* in 1847 and set up a school for 'ragged children'. The inscription on the statue summarises Guthrie's achievements: 'An eloquent preacher of the gospel, founder of the original ragged industrial schools, and by tongue and pen, the apostle of the movement elsewhere. One of the earliest temperance reformers. A friend of the poor and the oppressed.'

Royal Scots Greys Monument

This equestrian bronze depicts a Royal Scots Greys soldier in uniform with a bearskin hat, sword and rifle. The monument commemorates seven officers and sixty-seven soldiers of the regiment who fell in the Boer War. The monument, by William Birnie Rhind (1853–1933), was unveiled at an impressive and well attended ceremony by the Earl of Rosebery on 16 November 1906.

The inscription panel reads: 'In Memory of Officers, Non-Commissioned Officers and Men of The Royal Scots Greys Who Gave Their Lives For Their Country in the Boer War 1899–1902.' Plaques to commemorate the regimental fallen in the two World Wars were added later.

The eagle insignia on the plaque was adopted by the regiment after Ensign Ewart captured an eagle from the French at the battle of Waterloo in 1815. His granite memorial is on the Castle Esplanade.

Sir James Young Simpson Statue

The larger than life-size bronze statue depicts Sir James Young Simpson (1811–70) seated in a chair, dressed in professorial robes with a book on his knee, 'as if in act of addressing students'.

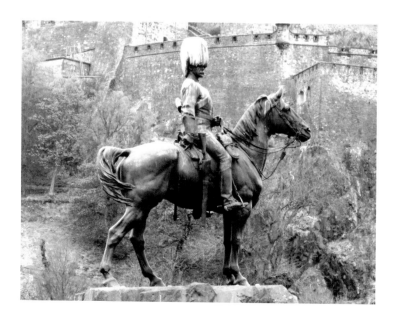

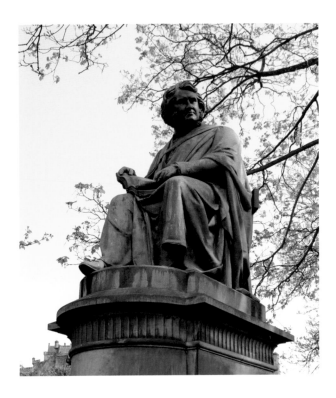

The statue was financed by public subscription and the Simpson Memorial Committee. The sculptor was William Brodie RSA (1815–81) and it was cast by Masefield & Co., bronze-founders, London. The statue was unveiled by Lady Galloway on 9 June 1877.

James Young Simpson was born in Bathgate, West Lothian, of humble origins and rose to become Professor of Midwifery at Edinburgh University in 1840. He pioneered the use of chloroform as an anaesthetic in childbirth and promoted its use against medical and religious opposition. He was appointed as the queen's physician in Scotland in 1847 and chloroform became generally accepted when it became known that Queen Victoria had used it giving birth to Prince Leopold in 1853.

The Dean Ramsay Memorial Cross

A Celtic cross made of unpolished Shap granite with ornate bronze relief panels depicting Christ's Passion, Resurrection and Ascension. The larger panels are filled with sculptured motifs based on designs from Jedburgh Abbey, which inspired the overall form of the cross by Sir Rowand Anderson.

Edward Bannerman Ramsay (1793–1872) was born in Aberdeen and graduated from Cambridge University in 1816. He came to Edinburgh in 1825 and worked as a curate at St George's and then at St John's Episcopal church, near to where the cross is sited. In 1841, he was appointed Dean of Edinburgh and later turned down offered bishoprics. Dean Ramsay wrote assorted religious books and the best selling *Reminiscences of Scottish Life and Character*. He was also responsible for having a statue of his great friend Thomas Chalmers erected in George Street.

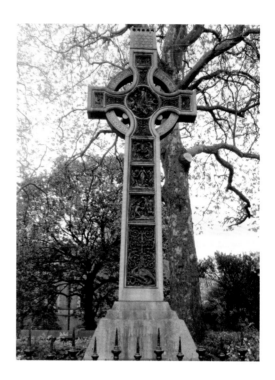

Scottish American War Memorial

The Scottish American War Memorial was presented as a tribute 'by people of Scots blood and sympathy in the USA, in commemoration of the Scottish effort in the Great War'.

A seated kilted soldier on a low plinth with a rifle across his knees gazes across to the castle and behind him is a long bronze bas-relief on a sandstone wall. The bronze figure represents 'The Call'. The plinth is inscribed:

> THE CALL 1914 A Tribute From Men and Women of Scottish Blood and Sympathies in the United States of AMERICA TO SCOTLAND. A People that jeoparded their lives unto the Death in the High Places of the Field JUDGES. V. 18.

The 30-foot-long (9 metres) bronze bas-relief symbolises 'the call to arms' and depicts a cross-section of Scottish working men – miners, shepherds, gamekeepers, farmers and fishermen – being led off to war by a regimental pipe and drum band. High on the wall are two intertwined wreaths containing shields, one bearing the Stars and Stripes and the other the St Andrew's cross. The inscription reads:

> If It Be Life That Waits, I Shall Live Forever Unconquered, If Death, I Shall Die, at Last, Strong In My Pride and FREE – lines from 'A Creed' , a poem written at Vimy Ridge in 1916 by Lieutenant E. Alan Mackintosh M.C.(1893–1917) of the 5th Seaforth Highlanders, 51st Highland Division.

The figure and relief were sculpted between 1924 and 1927 by Robert Tait Mackenzie (1867–1938), who was born in Ontario, Canada, of Scots parentage. The statue was cast at the Roman Bronze works in Brooklyn, New York.

The memorial was unveiled in September 1927 by the U.S. ambassador to Britain, Mr Alanson Bigelow Houghton, who was given the freedom of the city at the same ceremony. The sculptor, Robert Tait McKenzie, requested that his heart be buried under the memorial – this was refused by the city council. However, his heart was sent to Scotland after his death in Philadelphia. It was buried on 14 April 1938 near the south-east corner of St Cuthbert's church on Lothian Road, where there is a plaque with the initials: RTM.

The Royal Scots Regimental Monument

The monument consists of a semi-circular enclosure formed by rectangular standing stones with low relief carvings depicting regimental uniforms through the ages, from the formation of the regiment in 1633. The main stone (to the left) is incised with campaigns in which the regiment took part – from Tangier in 1680 to Burma in 1943–47 – and a large bronze plaque with the George Medal and the St Andrew's Cross. The stones are laid out so that each is progressively illuminated by the sun as it moves across the sky. The stones are linked by metal grilles with inscriptions and medallions. The monument was designed by the architect Sir Frank Mears and the stones were sculpted by Charles D'Orville Pilkington Jackson.

Along the railing is a quote from the Declaration of Arbroath: 'It is Not for Glory or Riches Neither is it for Honours that We Fight but it is For The Sake of Liberty Alone Which No True Man Loseth But at the Cost of His Life.'

At the right hand end the inscribed stone states:

This Monument Was Erected Under the Bequest of Campbell Smith, S.S.C., Edinburgh, a Pioneer of the Royal Scots Club and a Great Friend of the Regiment. It was Unveiled by H.R.H. the Princess Royal C.E.G., C.V.O., G.B.E., T.D., Colonel-In-Chief, on the 26th July in the First Year of the Reign of Queen Elizabeth II (1952).

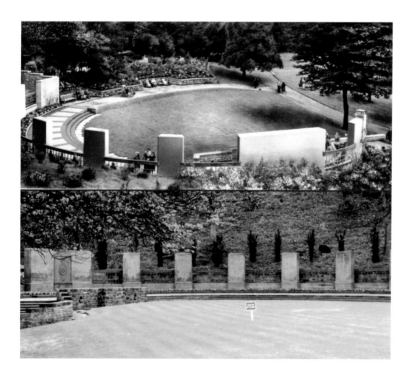

An additional plaque is inscribed: '1918–1965 H.R.H.Princess Royal, Colonel-In-Chief, the Royal Scots (Royal Regiment) for 47 years. This Stone was Unveiled by Her Majesty the Queen on July 1st 1968.'

On 9 May 2007, further plaques were unveiled by Princess Anne, the Princess Royal, commemorating the amalgamation of the regiment, the oldest in the British Army, into the newly formed Scottish Regiment. Other additions inscribed in the stone commemorate the regimental dead from more recent conflicts.

The Genius of Architecture

The sandstone statue of a standing female and two kilted children symbolises the Genius of Architecture Crowning the Theory and Practice of Art. The woman, representing Architecture, is depicted placing a garland of laurels on the head of a boy working on a column with a trowel (the practice) and the girl is holding an architectural drawing (the theory).

The statue was made for an International Exhibition in London in 1862, where the Ross Fountain was also displayed. It was sculpted by John Rhind and the female figure is modelled on Lady Gowans, wife of Sir James Gowans, Edinburgh's Lord Dean of Guild, 1884–85. The statue was later sited in the garden of Gowans' house, Rockville in Napier Road, Merchiston, and was gifted to the city in 1870.

Robert Louis Stevenson Memorial

Set in a grove of silver birch trees, this simple upright stone commemorates Robert Louis Stevenson and is carved with 'RLS – A Man of Letters 1850–94'. It was commissioned by the Stevenson Society in 1987 and designed by sculptor Iain Hamilton Finlay (1925–2006).

As a young boy Stevenson was often ill, and he developed a lively imagination which he translated into the classic novels *Kidnapped, Treasure Island, Dr Jekyll and Mr Hyde* and many

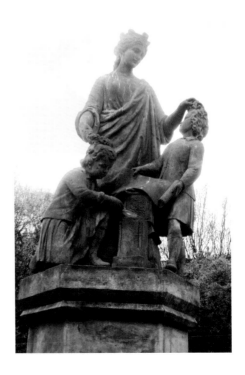

others. He was one of Edinburgh's most famous literary sons, who travelled much in his short life, ending his days in Samoa. Stevenson stated in his letters that he never wanted a statue of himself erected, and this small grove of trees below the castle is a fitting memorial.

The Ross Fountain

The Ross Fountain is a beautiful and intricately detailed example of nineteenth-century cast iron work which forms an ornamental foreground to Edinburgh Castle.

The circular fountain is a riot of decoration with stylised walrus heads, mermaid figures with overflowing urns, scallop-shell basins with lion's heads, swags, cornucopia, and cherub-faced spouts. Near the top are four female figures depicting Science, Art, Poetry, and Industry, seated between semi-circular basins. The structure is surmounted by a beautifully modelled female figure clutching a cornucopia.

The fountain was the creation of the Antoine Durenne iron foundry in Sommevoire, 150 miles south-east of Paris, France. The sculptures were by Jean-Baptiste Jules Klagmann, whose other work includes figures for the Louvre and D' Medici fountains in the Luxembourg Gardens in Paris.

A prototype of the fountain had been commissioned to appear alongside various other Durenne works for the International Exhibition held in London in 1862. One of the visitors to the exhibition was an elderly Edinburgh gun-maker and philanthropist, 'with inclinations to art and natural science', named Daniel Ross. The fountain had been described as 'obtaining universal admiration' and it caught the eye of Mr Ross, who decided to purchase it for the sum of £2,000 and subsequently gift it to the city. The fountain eventually arrived at Leith in 122 pieces in September 1869.

There was much debate about its location. Mr Ross had originally requested that the fountain be placed along the upper pathway of the gardens opposite Castle Street, while there were many who preferred other prominent sites such as Charlotte Square, George Street and Lothian Road. However, opinion was severely divided on whether it should be

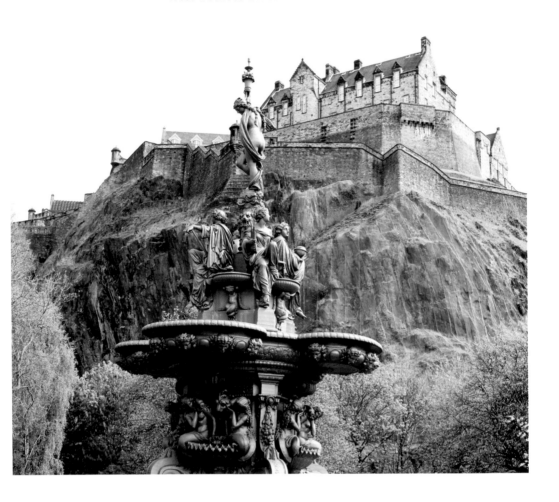

built at all. The fountain's abundance of sculptures of bare-breasted and voluptuous ladies pouring water down their chests was considered quite shocking to a section of Edinburgh society at the time. One of the most vehemently opposed was Dean Ramsay, of nearby St John's church, who labelled the nudity-laden structure, 'Grossly indecent and disgusting; insulting and offensive to the moral feelings of the community and disgraceful to the city.'

The Ross Fountain's eventual site, in a secluded location under the imposing shadow of the castle, appears to be the result of a heavily-debated compromise. It still didn't please everybody. As a response to the fountain's erection in the then private gardens, one objector complained, 'I am sorry for the Castle, rock and the garden, and the feelings of any decent-eyed person who cannot avoid seeing this unseemly, and in its present condition nonsensical erection.'

The fountain was finally unveiled in 1872 and it was agreed that it would operate 'on a Sunday and when the band plays'. The lengthy wrangles between the city authorities and establishment concerning the fountain meant that Mr Daniel Ross did not live to see the water flowing in his generous gift.

The fountain was extensively restored in 2001 and was able to spout water again for the first time in five years. Unfortunately, it has been mainly dry in recent years.

A Canine Connection, Bum The Dog

The bronze statue of a dog named Bum is located at the King's Stables Road entrance to Princes Street Gardens. The statue was presented to Edinburgh by the city of San Diego, California. Bum has a similar story to Greyfriars Bobby and the same iconic status in San Diego; and an exchange of statues of the two dogs was seen as a way of marking the link between Edinburgh and San Diego, which were twinned in 1978.

The unveiling ceremony on 19 July 2008 was preceded by a parade of dogs through Princes Street Gardens, led by members of the Skye Terrier Association in Victorian costume. Statues of Bum and Greyfriars Bobby had previously been unveiled in San Diego, in 2007.

Bum was a well-known character in San Diego and his life was documented in a blend of fact and fantasy by a local newspaper. Bum developed a taste for alcohol after hanging around bars and during a fight with a bulldog on a rail track, the two dogs were hit by a train, severing part of Bum's front right foot and killing the other dog. In the years that followed, Bum became the unofficial mascot of San Diego. After San Diego passed a byelaw in 1891 requiring all dogs to be registered, the city council granted Bum a tag for life 'on the grounds that he did more to advertise the city and county than most of the newspapers.' His image was stamped on all dog licenses issued in the city.

In 1894, Bum was injured again when his rear leg was fractured from a kick by a horse. By 1898, the free-roving town dog was having difficulty getting around because of arthritis. Bum was retired to the County Hospital, where he died on 19 November 1898 and was buried in the grounds.

Wojtek, the Soldier Bear

At the time of publication this is the newest statue to be erected in Edinburgh.

An over life-sized bronze statue of Wojtek with a Polish soldier mounted on a semi-circle of Polish grey granite with a bronze relief panel depicting the life of the soldier bear. The statue and setting were created by sculptor Alan Beattie-Herriot, funded by the Wojtek Memorial Trust and cast at Powderhall Bronze.

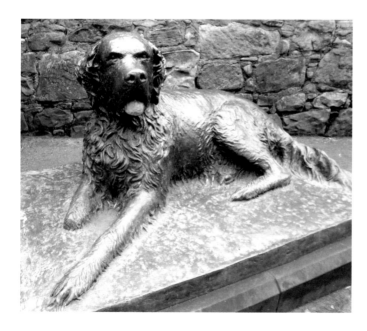

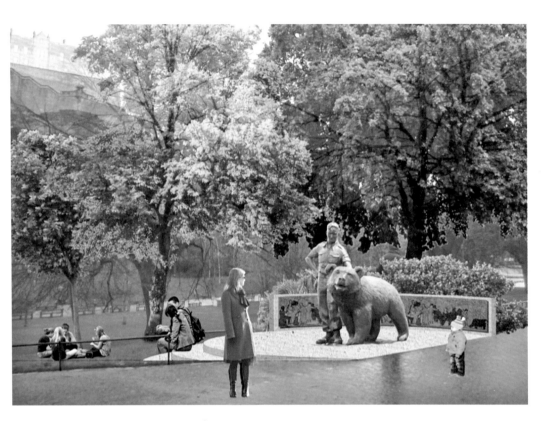

Image courtesy of Morris & Steadman.

In 1942, Wojtek, which means 'joyful warrior', was adopted as a young bear cub by soldiers serving in a unit of the Polish Army in Iran during the Second World War. Reared by the soldiers, he was fed fruit, marmalade, honey and syrup, and was often rewarded with beer, which became his drink of choice, and a cigarette. Wojtek would have play wrestles with the soldiers and was taught to salute. The bear became the mascot of the unit and to get him on a transport ship when the troops were moved to Italy, he was officially drafted into the Polish Army as a corporal. During the Battle of Monte Cassino, Wojtek helped by transporting ammunition and in recognition of his heroism and popularity, an effigy of a bear holding an artillery shell became the official emblem of the 22nd Artillery Supply Company. At the end of the Second World War, like many Polish soldiers, Wojtek came to Scotland and lived on a farm in Hutton in Berwickshire, where he became popular with locals and a bit of a media celebrity. He became an honorary member of the Polish-Scottish Association on 15 November 1947.

Following demobilisation in 1947, Wojtek went to live at Edinburgh Zoo where he spent the rest of his days. He was often visited by former Polish soldiers who would toss him cigarettes, which he then proceeded to eat because there was no one there to light them for him. When Wojtek died in December 1963, at the age of 21, he weighed 500 pounds (230 kg) and was over 6 feet (1.8 metres) tall.

The statue is a poignant reminder of the relationship between Wojtek and the soldiers he lived and fought alongside.

Calton Hill

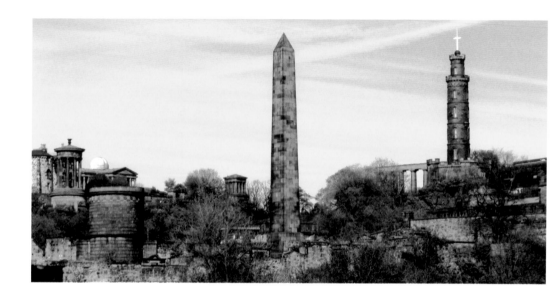

The National Monument

The twelve massive columns of the unfinished National Monument on Calton Hill are known as 'Edinburgh's Folly' or 'Edinburgh's Disgrace', and are said to represent 'the pride and poverty of Scotland'.

The plan for a National Monument to commemorate Scottish servicemen who died in the Napoleonic Wars was first discussed at a meeting of the Highland Society of Scotland in 1816. Supporters included Sir Walter Scott and Lord Elgin (who had removed sculpture from the Parthenon in Athens).

Plans were considered for triumphal arches and for a circular building based on the Pantheon in Rome. However, it was finally decided that the monument should take the form of a temple structure based on the Parthenon.

Charles Robert Cockerell was appointed architect and William Henry Playfair became his assistant. The building was to incorporate catacombs where illustrious Scots would be laid to rest.

The foundation stone was laid in 1822, and work started in 1826 with some of the largest pieces of stone ever taken from the Craigleith Quarry used in its construction – twelve horses and seventy men were needed to move some of the larger stones up the hill. During the first phase of the work, over the period 1826–29, the twelve pillars cost £13,500.

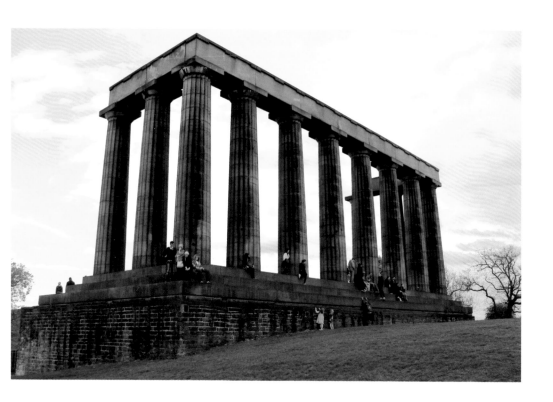

It was estimated that £42,000 was required for the work and despite generous subscriptions from many eminent people including George IV, the Duke of Atholl and Sir Walter Scott, only £16,000 was raised. By 1829, funding was exhausted and the project was abandoned.

There have been many plans for its completion but it remains just as it did when the scaffolding came down in 1829. Although incomplete, the Monument is central to Edinburgh's reputation as the 'Athens of the North'.

Nelson Monument

The Nelson Monument, at the highest point of Calton Hill, is one of Edinburgh's most prominent landmarks. It consists of a 100-foot-high (30 metres) battlemented circular stone signal tower, in the form of a telescope, rising from a pentagonal shaped ground floor building topped by a mast and a large white ball.

Inspired by Nelson's victory at Trafalgar, to commemorate his death and the desire to open a relief fund for the wounded and relatives of the war dead, a public subscription was opened and a site granted by the town council on 21 October 1807, the second anniversary of Trafalgar.

The Monument Committee adopted the plan of Robert Burn for a signal tower at a cost of £2,000, and the foundation stone was laid in 1807. Insufficient funds hampered progress and work stopped by the end of 1808. In 1814, a new committee was formed and Thomas Bonnar took over the supervision of the monument's construction, which was finally completed in 1816.

Over the entrance are two panels with the date of the Battle of Trafalgar in Roman numerals – MDCCCV (1805) – and a representation of Nelson's crest. The inscription reads:

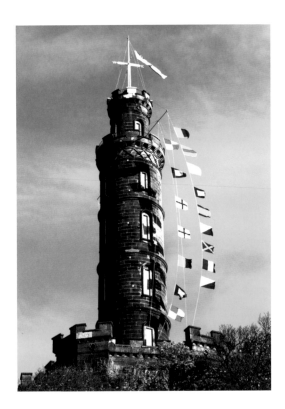

To the memory of Vice Admiral Horatio Lord Nelson, and of the great victory of Trafalgar, too dearly purchased with his blood, the grateful citizens of Edinburgh have erected this monument: not to express their unavailing sorrow for his death: nor yet to celebrate the matchless glories of his life, but by his noble example to teach their sons to emulate what they admire, and like him, when duty requires, to die for their country. MDCCCV.

In 1852/3, a time-ball mechanism was fitted at the top of the tower to provide a visual time signal for ships in the Firth of Forth to set their chronometers. The ball is raised just before one o'clock and is dropped exactly on the hour. Naval flags are hung every year on 21 October signalling: 'England Expects Every Man To Do His Duty.'

Dugald Stewart Monument

This circular stone monument in classical style was designed by the noted architect William Henry Playfair and, like the nearby Burns Monument, is based on the Choragic Monument of Lysicrates in Athens. The council granted permission for the monument in August 1830, and it was completed by September 1831. The inscription reads: 'Dugald Stewart. Born November 22 1753. Died June 11 1828.'

The monument was commissioned by the Royal Society of Edinburgh and was erected by public subscription to commemorate Dugald Stewart (1753–1828) – one of the great Scottish Enlightenment thinkers. He was Professor of Moral Philosophy at Edinburgh University and wrote *Elements of Philosophy of the Human Mind* as well as biographies of Adam Smith, William Robertson and Thomas Reid.

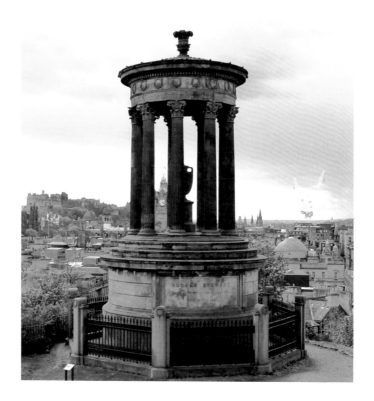

John Playfair Monument

A square stone temple-like monument in a Greek Doric style sited in the south-east corner of the Observatory wall. The monument commemorates John Playfair (1748–1819) and was designed by his nephew W. H. Playfair, the eminent architect. John Playfair was a distinguished mathematician and was Professor of Mathematics and Natural Philosophy at Edinburgh University from 1805, and was also the first President of the Astronomical Society.

The Latin inscription on the podium of the monument translates as follows: 'To John Playfair his friends' piety spurred on by constant longings in the place where he himself had once dedicated a temple to his Urania placed this monument 1826. Born 10 March 1748, Died 19 July 1819.'

The monument was originally proposed by the Royal Society of Edinburgh on 17 January 1820 and was completed in 1826. It was incorporated in the wall of the Observatory when it was built in 1828.

The Democracy Cairn

A stone cairn, topped with a brazier, made from stones from around Scotland and other specially identified stones. A plaque on the cairn provides details of its origin: 'This cairn was built by the keepers of the Vigil for a Scottish Parliament. The Vigil was kept at the foot of this road. It began on the night of the 10 April 1992 as news broke of the fourth consecutive Conservative General Election victory. It ended 1980 days later. The previous day, 11 September 1997, Scotland voted 'Yes, Yes' for her own Parliament. Erected by Democracy for Scotland, 10 April 1998.'

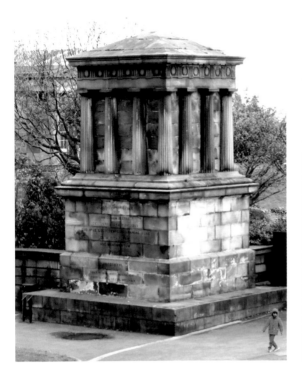
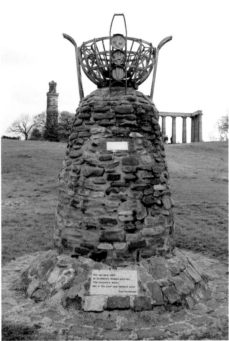

The origin of other stones on the cairn are identified by small plaques:
- On the twal hundreth day o' the Vigil for a Scottish Parliament, Julie 23rd 1995, a wheen o' Vigil fechtars brocht this stane frae the tap o Ben Nevis tae be biggit intil the Democracie Cairn.
- Destiny marches. 1993. Lochmaben. This stone from Bruce's castle represents an earlier struggle for self-determination by the people of Scotland.
- This stane was taen frae the Mauchlin hame o' Robert Burns and Jean Armour durin' the renovation in 1966 the bicentenary o the poets daith.
- 'The rank is but the Guinea's Stamp The man's the gowd for a that.'
- Paving stone from Paris used for defending democracy donated to the people of Scotland by supporters in Paris to commemorate the Auld Alliance.
- This stone from Auschwitz is in memory of Jane Haining Scottish Missionary and all others who died in the death camp.

Burns Monument, Regent Road
This outstanding circular temple to Robert Burns, the national poet, is a prominent landmark on the slopes of Regent Road. The design of the exceptionally well proportioned and detailed building is based on the Choragic Monument of Lysicrates of 334 BC in Athens. This type of monument was surmounted with a bronze tripod, which traditionally was given to the best orators in Greek theatre.

The idea to commemorate Burns was proposed by Mr John Forbes Mitchell at Bombay in 1812. The idea was not taken up at home until 1819, when, at a meeting at the Free Mason's Tavern in London, admirers of the Bard formed a committee under the chairmanship of the Duke of Atholl. The proposal was to erect a statue of Burns and, in July 1824, John

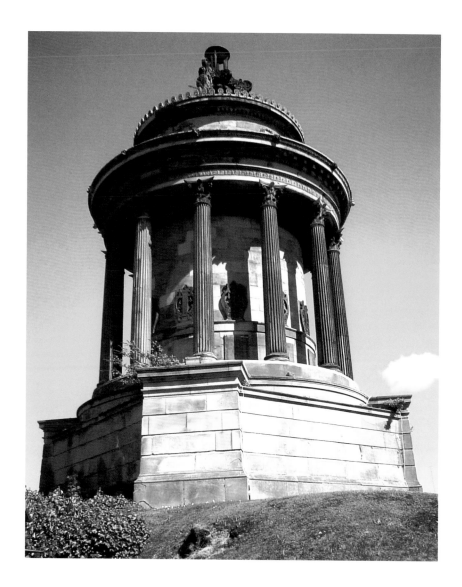

Flaxman (1755–1826), the prolific and famous sculptor, was commissioned to produce a life-size statue in marble. The public subscription raised more than enough money for the statue and it was decided to house it in a building.

Thomas Hamilton (1784–1858) was appointed as architect, as he had already designed the Burns Monument at Alloway in 1820 and the Royal High School opposite and did not charge for his work. Hamilton was one of the leading architects of the Greek Revival style, which was in vogue at the time.

The foundation stone of the monument was laid on 8 September 1831, and it was looked after by the Subscribers Committee until 1839, when it was handed over to the city. At this time it was suggested the statue of Burns should be moved, due to soot from a nearby gasworks which was affecting the marble. The statue is now in the entrance hall of the Scottish National Portrait Gallery on Queen Street.

Calton Old Burial Ground

The Political Martyrs' Monument

The Political Martyrs' Monument is a 90-foot-high (27.5 metres) monolithic obelisk which is the outstanding feature of Calton Burial Ground and is clearly visible from many points in central Edinburgh. The monument was designed by the prominent Edinburgh architect Thomas Hamilton (1784–1858), who is buried nearby. The inscribed dedication on the monument reads: 'To the Memory of Thomas Muir, Thomas Fyshe-Palmer, William Skirving, Maurice Margarot, and Joseph Gerrald. Erected by the Friends of Parliamentary Reform in England and Scotland 1844.'

The five Chartist Political Martyrs commemorated by the monument were members of the Edinburgh Society of the Friends of the People, a group that campaigned for electoral form in the eighteenth century. In 1793, they were found guilty of the trumped-up charge of treason for attempting to communicate with the French and were sentenced to transportation to the penal colony at Botany Bay in Australia – which amounted to a death sentence because of the dangerous conditions. The trial and sentence of Thomas Muir of Huntershill (1765–99), the founder of the Society of Friends, by the notorious Lord Braxfield (1722–99), the 'hanging judge', is said to have been the inspiration for Robert Burns to write 'Scots Wha Hae'.

The Scottish Reform Act of 1832 extended the right to vote, increasing the Scottish electorate from 5,000 to 65,000. The five martyrs were pardoned in 1838 and a public subscription in support of a monument to them was started. The foundation stone was laid by Joseph Hume, M.P., on 21 August 1844, with 3,000 people in attendance for the occasion.

David Hume Monument

> Within this circular idea,
> Called vulgarly a tomb.
> The impressions and ideas rest
> That constituted Hume.
>
> Robert Louis Stevenson

The David Hume Monument is a classical cylindrical tower designed by Hume's friend, Robert Adam. An engraved plaque above the entrance is inscribed: 'David Hume, Born April 26 1711. Died August 25 1776. Erected in Memory of Him In 1778.'

Hume, the great philosopher and historian, had given specific instructions about his burial in his will:

> I also ordain that, if I shall die anywhere in Scotland, I shall be buried in a private manner in the Calton graveyard and a Monument be built over my Body at an Expense not exceeding a hundred Pounds, with an Inscription containing only my Name with the Year of my Birth and Death, leaving it to Posterity to add the Rest.

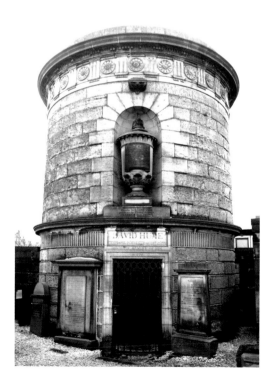

Hume's friends guarded his grave for eight days and nights to ensure it was not interfered with due to his religious scepticism.

The American Civil War Memorial

The American Civil War Memorial depicts a bronze life-sized standing figure of Abraham Lincoln (1809–65), holding the proclamation of emancipation in his right hand, with an unshackled slave at his feet. The free slave holds a book, indicating that he is not only free but also educated, and has an arm extended toward Lincoln in gratitude. The statue was designed by George Edwin Bissell (1839–1920), an American sculptor who was responsible for a number of Civil War memorials in the States. It was made in Edinburgh by Stewart McGlashen & Sons. The statue was a gift from America to Scotland and all the money was raised in the States. It was dedicated on 21 August 1893.

The memorial also incorporates furled regimental battle flags, indicating that the battle is over, and bronze shields with US flags, one wreathed in thistles and the other in cotton. It is the only monument commemorating the American Civil War outside of the United States. The memorial is inscribed: 'Emancipation Education Union Suffrage. To Preserve the Jewel of Liberty in the Framework of Freedom. Abraham Lincoln. In Memory of Scottish-American Soldiers. Unveiled 21 October 1893.'

The monument commemorates six Scottish men who fought and died on the Union side in the American Civil War – the names of Sergeant Major John McEwan, Lietenant Colonel William Duff, Robert Steedman, James Wilkie, Robert Ferguson and Alexander Smith are inscribed on the granite plinth of the statue.

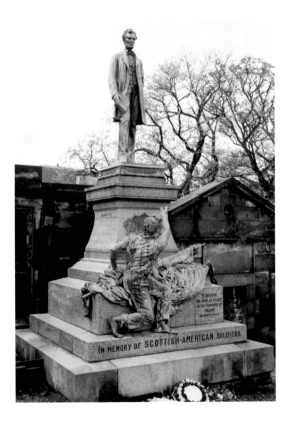

New Town

Duke of Wellington Statue, Princes Street

The bronze statue of the Duke of Wellington (1769–1852), hero of the Battle of Waterloo in 1816, stands in front of Robert Adam's Register House. It was the work of Sir John Steell and was cast at his specialist foundry on Grove Street.

It was unveiled on 18 June, 1852, the anniversary of the battle, by the Duke of Buccleuch. The day had been declared a public holiday and the event was attended by thousands of spectators. There was a large procession, military bands played and a salute was fired from the castle.

The bronze statue depicts Wellington in a heroic pose mounted on his war horse, Copenhagen, with his right arm raised. The design of the horse is clever, with a hollow body and head counterbalanced by the weighted tail which is solid inside, allowing the

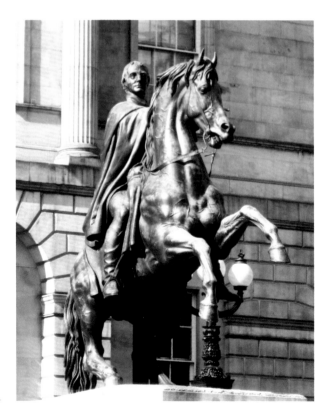

The Iron Duke in Bronze by Steell.

horse to 'rear up'. The duke was so pleased with this statue that he ordered two copies for his own homes.

John, 4th Earl Of Hopetoun Statue, St Andrew Square

A life-size bronze pedestrian statue of General John Hope, 4th Earl of Hopetoun (1765 –1823) in Roman costume standing with a pawing horse by the sculptor, Thomas Campbell. The Town Council commissioned the statue as a centrepiece for Charlotte Square, but in 1834 it was located in front of Dundas House in St Andrew Square, which has been the headquarters of the Royal Bank of Scotland since 1825 – Hope was vice-governor of the bank from 1820 to 1823. The earl was a politician and British Army officer who was a hero of the Peninsular War. The inscriptions read:

> To John, Fourth Earl of Hopetoun, Erected by the Gratitude of His Countrymen, Who Loved and Reverenced in His Person the Assembled Virtues of Distant Periods Of History, The Unshaken Patriotism of the Ancient Roman, The Spirit Of Honour, and Gentleness, and Courtesy Proper to the Age of Chivalry, Together With Skill in the Art of War, Worthy of the Companion of Abercromie, Moore And Wellington.

The Melville Monument, St Andrew Square

This imposing monument consists of a 136-foot-high (42 metres) stone column surmounted by a statue of Henry Dundas, 1st Viscount Melville (1742–1811).

Dundas was a dominant force in British politics for over four decades, and has been described as the 'uncrowned King of Scotland'. He served as treasurer for the navy, Home Secretary, secretary for war, and lord advocate for Prime Minister William Pitt. He was

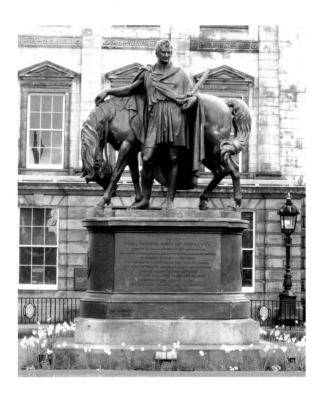

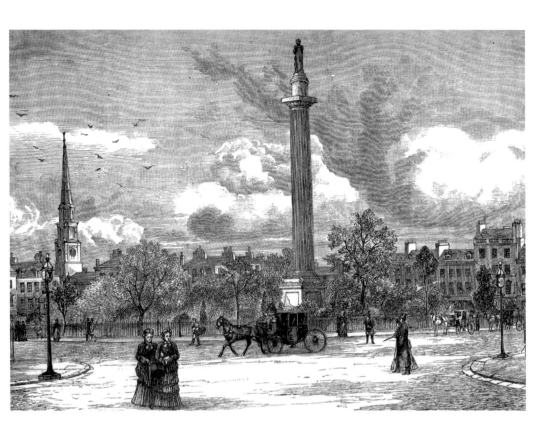

opposed to the emancipation of slavery and was the last person in Britain to be impeached, in 1806, for embezzlement of naval funds.

The idea of erecting a monument originated with a group of naval officers to commemorate Hope's service as First Lord of the Admirality. A committee was formed in 1817 and almost £3,500 was raised for its construction.

The fluted column has an internal staircase and the ornate base has an acanthus leaf decoration with eagles at each corner. It was designed by architect William Burn. There were concerns about the safety of the column and Robert Stevenson (1771–1850), father of Robert Louis Stevenson and a renowned lighthouse designer, assisted with the design.

The 14-foot-high (4.2 metres) statue of Viscount Melville, carved by Robert Forrest, was not part of the original design and was added to the column later. The reason given for this was that the column was erected to include a statue of George IV. However, due to displeasure with the king, Lord Melville was included as an afterthought.

Lion of Scotland, St Andrew Square
The magnificent 17-foot-long (5 metres) *Lion of Scotland* sculpture was carved from a twenty-ton boulder of pink Aberdeenshire granite by sculptor Ronald Rae. The sculpture was first sited in Holyrood Park and moved to St Andrew Square Gardens in 2010.

James Clerk Maxwell Statue, St Andrew Square/George Street
The statue depicts a seated James Clerk Maxwell (1831–79) holding a spinning disk, with

his dog, Toby, at his feet. The statue by Alexander Stoddart was unveiled on 28 November 2008 by Alex Fergusson, the then presiding officer of the Scottish Parliament.

Maxwell was one of the most influential physicists of all time. His discoveries of the laws of electrodynamics sparked a revolution. Modern-day electronics, radio, television, mobile phones, the internet, would not have been possible if it had not been for the pioneering work of a man once nicknamed 'dafty' by his school classmates. The spinning top which Maxwell is shown holding in the statue relates to his study of the nature of colour, which led him to produce the world's first colour photograph in 1861.

Statue of George IV, George Street and Hanover Street

This pedestrian bronze statue of George IV (1762–1830) on a granite plinth was funded by public subscription under the chairmanship of Lord Meadowbank. Sir Francis Chantry (1781–1841) was the sculptor and it was unveiled on 26 November 1831.

The statue commemorates the visit of George IV to Edinburgh in 1822, the first visit to Scotland by a monarch since the Union of the Crowns. The visit was orchestrated by Sir Walter Scott, who persuaded the king and the assembled dignitaries to wear tartan, which had previously been outlawed.

Statue of William Pitt, George Street and Frederick Street

The pedestrian bronze statue of Pitt on a Craigleith stone plinth was erected in 1833 and sculpted by Sir Francis Chantrey (1781–1841). It was built at the instigation of the Pitt Club under the chairmanship of Lord Meadowbank. It commemorates William Pitt (1759–1806), the statesman and Tory politician who became Britain's youngest prime minister at the age of twenty-one. He introduced income tax particularly to help pay for the Napoleonic Wars and was from the royal Stuart line, his grandmother a descendant of James I.

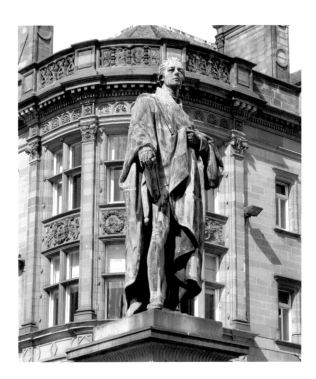

Statue of Dr Chalmers, George Street and Castle Street

A 12-foot-high (4 metres) pedestrian bronze statue of the Reverend Thomas Chalmers D.D. (1780–1847), by Sir John Steell. Chalmers studied mathematics and natural philosophy before turning to the ministry and was appointed Professor of Divinty at Edinburgh in 1828 – he has been called 'Scotland's greatest nineteenth-century churchman'. In 1843, he became Moderator of the Free Church of Scotland, after a withdrawal of 470 ministers from the general assembly due to a dispute over Church law.

The statue was first proposed by Dean Ramsay, who is commemorated with a Celtic cross on Princes Street, in 1847. However, it was not until November 1869, when the Earl of Dalhousie chaired a fundraising committee, that a public subscription raised £3,000. The statue was unveiled in July 1878.

The Prince Consort Memorial, Charlotte Square

This elaborate equestrian bronze statue commemorates Prince Albert (1819–61). It depicts the prince in field marshal's uniform and stands on an oblong plinth of Peterhead granite, with bas-reliefs on four sides and groups of figures projecting at the corners of the plinth. The bas-reliefs, by William Brodie and Alexander Handyside Ritchie, show scenes from the prince's marriage, the opening of the Great Exhibition in 1877, and the domestic and artistic tastes of the prince.

The corner statues paying homage to Albert are: Nobility ('A Peer and his lady doing Homage') by William Brodie, Army and Navy by Clark Stanton, Science and Learning by D. W. Stevenson and Labour, also by D. W. Stevenson from a sketch by George McCallum. A figure in Highland regalia with bearskin cap in his hand paying respect to the Prince Consort, is probably based on John Brown, the ghillie who befriended Queen Victoria and Prince Albert.

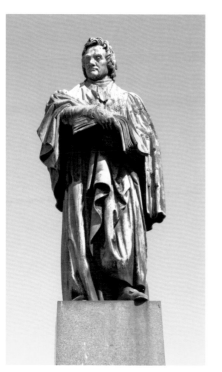

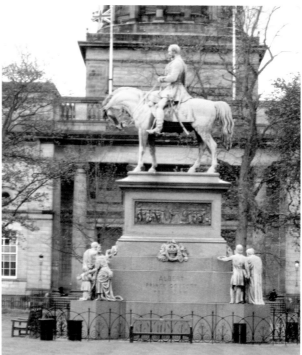

The statue was built by public subscription as a Scottish national memorial to Prince Albert, the Prince Consort, who died in 1861. It was officially inaugurated on 17 August 1876 by Queen Victoria.

The memorial was designed by David Bryce and the main statue sculpted by Sir John Steell, who was knighted by Queen Victoria at Holyrood Palace on the day of the unveiling.

Catherine Sinclair Monument, Charlotte Street North/St Colme Street

Catherine Sinclair was born in Edinburgh on 17 April 1800. She was one of thirteen children of Sir John Sinclair, a prominent and prosperous politician, and Lady Diana Macdonald.

Catherine wrote many bestselling books in a variety of genres – novels, children's literature and travelogues. Her most popular book was *Holiday House*, which was written for children and published in 1839. It was considered a milestone in children's literature for its portrayal of two realistic rebellious children and was a nursery favourite for decades. She is also noted as the person who discovered that Sir Walter Scott was the author of the Waverley novels, which were originally published anonymously.

Catherine was most celebrated for her wide-ranging charitable work and as one of the most prominent philanthropists of nineteenth century Edinburgh. She introduced public bench seats to the city, a feature which remains popular to this day. She founded and financed the Volunteer Brigade for the boys of Leith, opened a school where girls from working class homes were taught domestic work, provided shelters where cabmen could relax while waiting for 'fares', and opened special cooking centres which provided low cost meals for the poor.

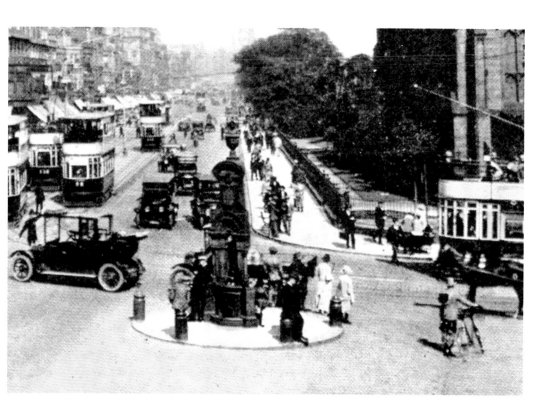

She is perhaps best remembered for the Catherine Sinclair Drinking Fountain, which was erected at the west end of Princes Street in 1859 and was the first drinking fountain in Edinburgh. It was a popular amenity and the inscription on the fountain read 'Water is not for man alone', as it provided facilities for both people, dogs and the horses that pulled the Edinburgh cabs to quench their thirst. Due to the increase in traffic, the fountain was dismantled in 1932. The fountain lay in storage until 1983, when parts of it were re-erected on the Water of Leith Walkway at Gosford Place.

The monument was built by public subscription shortly after her death. It was designed by David Bryce and carved by John Rhind. The inscription reads:

Catherine Sinclair. Born 17th April. 1800 Died 6th August 1864. She was the friend of all Children, and, through her book 'Holiday House', speaks to them still. Besides success in her writings, which were many and popular, she was an early pioneer in philanthropy. Her volunteer brigade, for the boys of Leith, was the first of its kind. She initiated cooking depots for working men and erected a drinking fountain on Lothian Road/Princes Street in 1859. Her hall for lectures and her work among cabmen endeared her name to different sections of her fellow citizens. This Monument was raised by some of her many friends. The inscription, except the name and dates, was added in 1900 by her affectionate nephew, Sir Tollemache Sinclair, Bart., of Ulbster, Caithnessshire.

West End

Woman and Child Statue, Festival Square, Lothian Road
The bronze figure of an African woman and child standing in front of a representation of a shanty home was sculpted by Anne Davidson. The statue was erected in Festival Square by the City of Edinburgh District Council to honour all those killed or imprisoned for their stand against apartheid. The statue was unveiled on 22 July 1986 by Suganya Chetty, a member of the African National Congress who was then living in Edinburgh. The inscription at the base of the statue is, 'Victory is Certain.'

Heart of Midlothian FC War Memorial, Haymarket
A square stone pillar with twin clocks, surmounted by a stone pinnacle, and decorated with lions' heads at each corner. It was designed by H. S. Gamley, and built by John Angus & Sons.

Bronze plaques read:

Erected by the Heart of Midlothian Football Club to the Memory of Their Players and Members Who Fell in The Great War 1914–18.
 In Honoured Memory of the Players and Members of the Heart Of Midlothian Football Club Who Lost Their Lives in the Second World War 1939–1945.

Carved in stone on the four corners are the battle honours:

VIMY, SOMME, ST. ELOI, AFRICA, GAZA
MONS, AISNE, HILL 60, HOOGE, EGYPT
ARRAS, LILLE, CAMBRAI, FRESNES, STRUMA
MAME, LOOS, YPRES, YSER, JUTLAND

It was unveiled before a large group of spectators, by the Right Honourable Robert Munro, K.C. M.P., Secretary for Scotland on 9 April 1922. In the inaugural speech, Munro paid tribute to the bravery and patriotism of the eleven Hearts players who had enlisted in autumn 1914.

2nd Viscount Melville Statue, Melville Crescent

This pedestrian bronze statue by Sir John Steell commemorates the 'regard and esteem' in which Robert Saunders Dundas, 2nd Viscount Melville (1771–1851) was held by his 'friends and countrymen'. Robert Dundas became MP for Midlothian in 1800, and held the posts of President of the Board of Trade, Secretary for Ireland, First Lord of the Admiralty, and was Tory 'manager' of Scottish political affairs. The statue was unveiled on 1857, on a site originally allocated for a monument to Robert Dundas' father, who is commemorated by the Melville Monument in St Andrew Square.

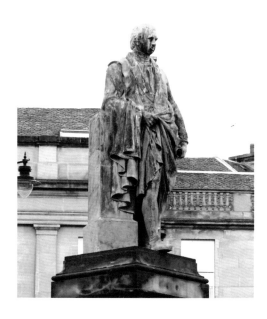

The Gladstone Memorial, Coates Crescent

This monumental memorial depicts William Ewart Gladstone as a statesman in the uniform of a Privy Councillor under the robes of the Chancellor of the Exchequer. Gladstone was a Liberal politician and Member of Parliament for Midlothian, who later became prime minister in 1868, 1880, 1886, and 1892. He also rebuilt Edinburgh's Mercat Cross in 1885.

Sculpted by James Pittendrigh McGillvray, and cast in bronze by Singers of Frome, Somerset, Gladstone towers over eight subsidiary bronze figures on a 'Renaissance' pedestal of red Aberdeen granite.

At the foot of the central column, are four allegorical figures representing Gladstone's virtues:
- Faith – clutching a Bible;
- Measure – holding a Roman steelyard;
- Fortitude – with a shield depicting Christ's thorn-crowned head;
- Vitality – with the lamp of life.

At each side two larger figures are seated – Eloquence and History (with hooded cape). A local girl, Elizabeth Stark, a waitress in Thomson's store, is reputed to have modelled for these figures for two years without telling her mother.

At the front are two boys, placing a laurel wreath on a tripod with ribbons trailing from it and phrases from Homer's *Iliad*: 'Whose eager heart and manly spirit excel and from whose tongue also flowed speech sweeter than honey.' The three birds of prey – kites or 'gleds' – are an allusion to the old family name of 'Gledstane'.

Although originally sculpted for this site, it was opposed by local residents and was originally unveiled on the west side of St Andrew Square by the Earl of Roseberry on 18 January 1917. In 1955, it was moved to its present site.

Horse and Rider, Rutland Court

The dramatic *Horse and Rider* statue at Rutland Court is by the Edinburgh-born sculptor Eoghan Bridge. It was commissioned in 1993 by the firm of Baillie Gifford and stands outside of the company's office.

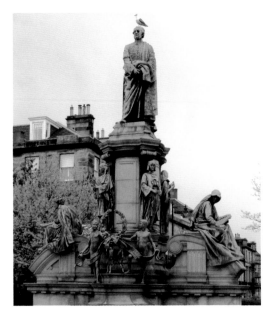

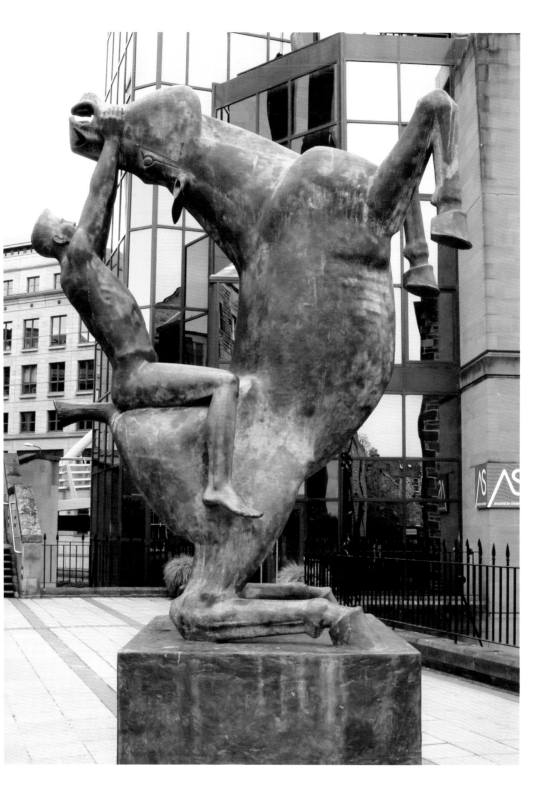

South Side

Brassfounders' Column –Tubal Cain, Nicolson Square

The Brassfounders' Column was designed by Sir James Gowans as a showpiece for the Brassfounders' Guild of Edinburgh and Leith for the Meadows' International Exhibition in 1886 – it won a gold medal. The pillar was also shown at the Scottish National Exhibition of 1908 in Saughton Park, after which it was offered to the city as a gift.

The bronze column is decorated with plaques showing heraldic devices and coats of arms. It is surmounted by a sculpture, by John Stevenson Rhind (1859–1937), of Tubal Cain, the Biblical blacksmith who, according to Genesis, was an 'instructor of every artificer in brass and iron'.

The bronze plaque on the base states: 'Executed and Erected by the Brassfounders of Edinburgh and Leith in Commemoration of the International Exhibition of 1886 and Presented to the City by the East of Scotland Brassfounders Society, 1909. Designed by James Gowans, Lord Dean Of Guild Of Edinburgh.'

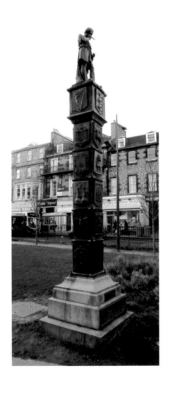

William Chambers Statue, Chambers Street

The bearded William Chambers stands hand on hip, holding a roll of papers, in the robes of Lord Provost. The statue was erected in 1891 and was commissioned and paid for by Edinburgh Town Council, at a cost of £1,400.

William Chambers was a printer, writer and publisher who became Lord Provost of the city from 1865–69. He was a great benefactor to Edinburgh, initiating many improvement schemes.

The bronze figure was sculpted by John Rhind, possibly with the help of his son William Birnie Rhind. The red sandstone pedestal with a stepped-up granite base has swags and scrolls on the cornice. On three sides are bas-reliefs of women representing Literature, Liberality and Perseverance, which were designed by Hippolyte J. Blanc, and cast at the foundry of William Shirreffs. The fourth side has two inscribed plaques:

> William Chambers of Glenormiston L.L.D. Lord Provost of Edinburgh 1865 1869 Born 16 April 1800 Died 21 May 1883 and Erected by the Lord Provost Magistrates and Council 1891. The Right Honorable John Boyd Lord Provost.

McEwan Lantern, Bristo Square

A Portland stone tower carved with scrolls and dancing cherubs, topped by an ornate cast iron lantern at the front of the McEwan Hall. The lantern includes the inscription:

> Donated to the city of Edinburgh by William McEwan, Member of Parliament, and the McEwan family crest of a lion and bunch of wheat. The lantern dates from 1887 and was designed by Sir Robert Rowand Anderson, the architect of the McEwan Hall.

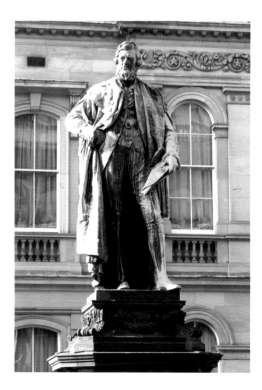

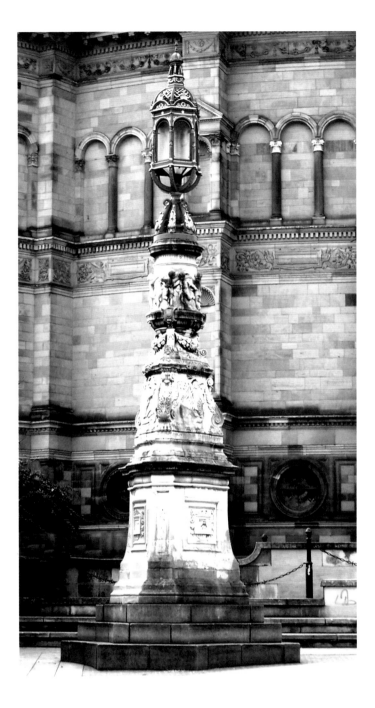

The hall and lantern were funded by Sir William McEwan (1827-1913), the Edinburgh brewer who established the successful Fountain brewery in Edinburgh in 1856. McEwan became M.P. for central Edinburgh in 1886 and gave £115,000 to the University of Edinburgh to erect a graduation hall.

The Meadows

Most of the monuments in the Meadows are from the 1886 International Exhibition of Industry, Science and Art, which was organised by Sir James Gowans (1821–90), who was knighted by Queen Victoria at the exhibition.

The Memorial Masons' Pillars, Melville Drive

The two Memorial Masons' Pillars which flank each side of the west end of Melville Drive were erected to serve as an example of stone craftsmanship for the International Exhibition in 1886. They were designed by Sir James Gowans, who was also a quarry owner with a great interest in stone, and constructed by the master builders and operative masons of Edinburgh and Leith as a gift to the City of Edinburgh.

The 26-foot-high (8 metres) pillars are octagonal in plan and surmounted by 7-foot-high (2 metres) unicorns. They are decorated with shields displaying the Imperial, Scottish, English and Irish arms; the coats of arms of nineteen Scottish Burghs; and the crest of the Edinburgh Masons.

The stones in the pillars consist of eighteen courses of specimen stone from seventeen different quarries – the name of the source of the quarry is inscribed on each course. The pillars also show examples of different types of stone finishes and masons' marks. Gowans intended the pillars to act as a durability test of the different stones.

In the early 1970s, the pillars were moved 45 feet (14 metres) from their original location due to a new traffic control system.

The Prince Albert Victor Sundial

The sundial at the west end of the Meadows was designed by Sir James Gowans and erected to commemorate the opening of the International Exhibition by Prince Albert Victor. The sundial was built by Brysons, 'eminent Edinburgh horologers'. It was gifted to Edinburgh Town Council on 10 May 1886 by the Exhibition Committee.

The sundial consists of an octagonal stone column topped by an armillary sphere – an astronomical device. Each section of the column is inscribed: 'Myreton, Redhall, Cocklaw, Cragg, Whitsume Newton' – the names of the quarries which were the source of the stones.

The sundial is inscribed with mason's marks and appropriate lines:

> I mark but the hours of sunshine. Time and tide wait for no man. Light is the shadow of God. Time is the chrysalis of eternity. As a servant earnestly desireth the shadow. Time, as he passes us, has a dove's wing, unsoiled and swift, and of a silken sound. Man's days are as a shadow that passeth away. Well-arranged time is the surest sign of a well-arranged mind.

Around the top of the column is inscribed: 'Tak Tent o' Time Ere Time Be Tint – Take care of time before time is taken from you.'

Jawbone Arch

The arch at the Melville Drive entrance to Jawbone Walk in the Meadows is formed from four whale jawbones and was part of the stand of the Shetland and Fair Isle Knitters' exhibition at the International Exhibition. After the exhibition, they were gifted to Edinburgh Town Council by Sheriff Thoms. They were accepted by the Council on 1 February 1887. Each jawbone has the inscription: 'From Zetland Fair Isle Knitting Stand. International Exhibition 1886.'

Sister Cathedral Fountain

This small granite drinking fountain with a circular basin was originally topped by a bronze dolphin. It is a memorial to Helen Aquroff (1831–87). Helen was blind from birth and taught music at the Blind Asylum School on Nicolson Street. She was a popular singer in the city's concert halls and an ardent champion of the Temperance Movement, adopting the name Sister Cathedral.

The fountain is inscribed: 'Helen Acquroff Sister Cathedral/1889 and Erected by Members of the I.O.G.T./and Other Friends.' The I.O.G.T is the Independent Order of Good Templars, who were the main subscribers.

When it was built in 1889, custody was offered to Edinburgh Town Council. The fountain had a drinking spout installed in 1951, but due to public health regulations it is no longer in use.

Nelson Pillars, Melville Drive

Thomas Nelson opened a second-hand bookshop in Edinburgh's Old Town in 1798, from which he started to publish inexpensive reprints of classic books. This proved profitable and in 1845, Nelson's established a printing-house at Hope Park.

In 1878, Nelson's works at Hope Park burnt down in a spectacular fire and they were allowed to erect temporary accommodation for the business in the East Meadows. The company moved back into new premises at their new Parkside Works on Dalkeith Road in 1880. In 1881, the company donated the two columns at the east end of the Meadows in: 'Commemoration of the kindness and sympathy shown to them by the magistrates at the time of the great fire in 1878. The north-pillar is topped by a lion rampant, the south-pillar by a rampant unicorn – each with the coat-of-arms of Edinburgh on a shield.'

In the early 1960s it was discovered that the stonework was in very poor condition, and, following repair, they were re-erected 45 feet (14 metres) west of their original site.

Leith Walk

The Omni Giraffes – Dreaming Spires, Picardy Place

A mother giraffe and her calf tower above pedestrians at the front of the glass facade of the Omni Centre on Picardy Place. The sculptures, the largest of which is 24 feet (7.3 metres) high, were made of recycled scrap metal from motorbikes and cars by the artist Helen Dennerly.

They are officially titled *Dreaming Spires,* but are known affectionately by the nicknames Martha and Gilbert. A poem by Roy Campbell in bronze letters circles the giraffes: 'Giraffes – a people who live between earth and skies each in his own religious steeple keeping a lighthouse with his eyes.'

Martha and Gilbert were unveiled by Julian Spalding on 27 July 2005.

The Manuscript of Monte Cassino (the 'Big Foot')

This large three-piece sculpture outside St Mary's Cathedral is an allegory of a pilgrimage: the foot of the travelling pilgrim, the connecting ankle and the hand receiving alms or hospitality.

The sculpture by Eduardo Paolozzi was funded by Tom Farmer CBE and the City of Edinburgh Council, and inaugurated on 6 September 1991.

Professor Sir Eduardo Luigi Paolozzi (1924–2005) was born next to the old Leith Central station and fragments from this building surround the sculpture. His family came from the Monte Cassino area of Italy, which was devastated during the Second World War. He became Her Majesty's Sculptor in Ordinary for Scotland in 1986 and was knighted in 1989.

Paolozzi said of the work: 'Edinburgh, with its fine historic architecture must be complemented with works of suitable grandeur, with sculpture of the right scale and material on a theme that reflects the everlasting inspiration that the city has drawn upon from classical models. The foot can be considered to be inspired (or reinvented) by the foot of Constantine in Campidoglio in Rome. On the site I can see these very parts of the landscape that were the back-cloth to my childhood. A great deal has disappeared, which makes it a privilege to add something significant to what might have become an urban gap.'

The Latin inscription is taken from an ancient poem, 'Manuscript of Monte Cassino':

Letter from my hand
Go now with swift and easy flight
As you pass without delaying
Through woods, hills and valleys
Seek out the welcoming house
of Benedict, loved by God.
There the weary always find rest;
for guests there is an abundance
of garden herbs, fish and bread.
Among the brethern there is consecrated peace,
lowliness of heart, / and uplifting harmony
as they come together at every hour
to offer praise to Christ
in love and adoration.

Sherlock Holmes Statue

The larger than life-size bronze pedestrian statue of Sherlock Holmes represents the literary creation of Sir Arthur Conan Doyle (1859–1930), who was born in Picardy Place. Holmes,

the famous literary detective, is depicted meditating on the death of his author. His pipe is inscribed with the words *'Ceci n'est pas une pipe'*, in homage to the surrealist Magritte, and there is a footprint of a hound of the Baskervilles on the bronze pedestal. It was sculpted and cast by Gerald Ogilvie Laing.

The inscription reads:

In Memory of Sir Arthur Conan Doyle, Born on 22 May 1859 Close to This Spot. Donated to The City Of Edinburgh by Edinburgh and Lothians Branch of The Federation of Master Builders on The Federation's 50th Anniversary. Unveiled on 24 June 1991 by Professor Geoffrey D. Chisholm.

Leith

Queen Victoria Statue, Foot of Leith Walk

The bronze pedestrian statue of Queen Victoria on a sandstone plinth at the 'Fit o' the Walk' is one of Leith's best-known landmarks. It was conceived and built under the supervision of the Leith Queen Victoria Statue Fund and was designed by John Stevenson Rhind. Lord Roseberry unveiled the statue in front of a large crowd of 20,000 people on 12 October 1907.

A bronze plaque on the south face of the plinth reads: 'Queen Victoria 1837–1901 Empress of India 1877–1901 Erected 1907.' A panel on the east side depicts a military scene, commemorating the part played by the Leith Volunteers (5th Battalion Royal Scots) in the Boer War (1900–02) – '5th Volunteer Battalion The Royal Scots South Africa 1900–02. A Memorial To Patriotism and Loyalty.' A further panel was added in 1913 to the west side depicting: 'Queen Victoria Entering Leith Sept. 3 1842.'

The statue has been moved twice – in 1968 and 2002.

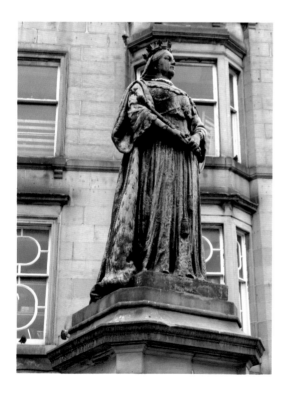

Robert Burns Statue, Bernard Street

Robert Burns (1759–1796), the National Bard of Scotland, is depicted in more statues around the world than any other literary figure. The bronze statue of Burns stands on a red sandstone and granite plinth on Bernard Street in Leith, and shows Burns with a plaid over his shoulder. It was commissioned by the Leith Burns Club to celebrate Scotland's greatest poet. *The Scotsman* reported that a 'holiday mood' prevailed as thousands gathered on Bernard Street on 15 October, 1898 for its unveiling by Mr R. C. Munro Ferguson, M.P., when it was offered to the Lord Provost of Leith, who accepted it on behalf of the burgh.

The plinth includes four bronze bas-relief panels depicting scenes from poems by Burns:

- South. 'The priest like father reads the sacred page. From scenes like these old Scotia's grandeur springs, that makes her loved at home, revered abroad.'
- East. From the poem 'Scotch Drink' – 'When Vulcan gies his bellows breath an' plowmen gather wi' their graith.'
- West. From the poem 'Hallowe'en' – 'In order on the clean hearth staine, the luggies three are ranged.'
- North. From the poem 'Death and Doctor Hornbook' – 'I there wi' something did foregather, that put me in an eerie swither.'

The statue is by the eminent Ratho-born sculptor David Watson Stevenson (1842–1904) who, in 1900, had sculpted a bust of William Ewart Gladstone. It is, therefore, perhaps no coincidence that the figure of the blacksmith on the plaque illustrating the poem 'Scotch Drink' bears a striking resemblance to Gladstone, who was Leith's Member of Parliament. In 1961, the statue was moved 18 feet (5.5 metres) to the west to ease the flow of traffic at the junction. In 2004, the statue was again moved a short distance, to take centre stage in a new pedestrian area.

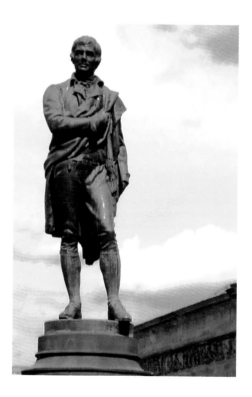

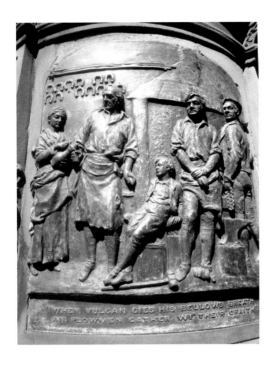

Sandy Irvine Robertson, The Shore

Sandy Irvine Robertson was a wine merchant and founder of the Scottish Business Achievements Awards Trust. He is depicted relaxing on a bench in this life-size bronze sculpture which was installed in 1999. A plaque on the bench reads: 'Sandy Roberston Irvine OBE. 11th August 1942 – 20th June 1999. Commissioned by his friends. Sculpted by Lucy Poett.'

Bust of John Hunter, The Shore

John Hunter (1737–1821) was born in Leith and was Governor of New South Wales between 1795 and 1800. The inscription on the attached bronze plaque reads:

> Governor John Hunter Governor of New South Wales 1795–1800. Born Leith 29th August 1737. Died London 13th March 1821. John Hunter, Son of a Leith Ship Master, was Second in Commmand Aboard H.M.S. Sirius to Governor Arthur Phillip who Founded the Colony in January 1788. He Returned to be the Colony's Second Governor and Conducted Its Government With Sense, Duty, and Humanity. This Bust was Donated to the Scots Australian Council in Edinburgh by its Sculptor, Victor Cusack, and the Scottish Australian Heritage Council in Sydney and was Unveiled on 28th August 1994, by the Rt. Hon. Norman Irons, the Lord Provost of the City of Edinburgh, and His Excellency, the Hon. Neal Blewett, High Commissioner for Australia.

Merchant Navy Memorial, The Shore

The Merchant Navy Memorial is an 18-foot-high (5.5 metres) sandstone column featuring seafaring scenes in bronze relief which tell the story of Scotland's relationship with the sea. It was designed by artist Jill Watson and made at Powderhall Bronze.

The inscription reads:

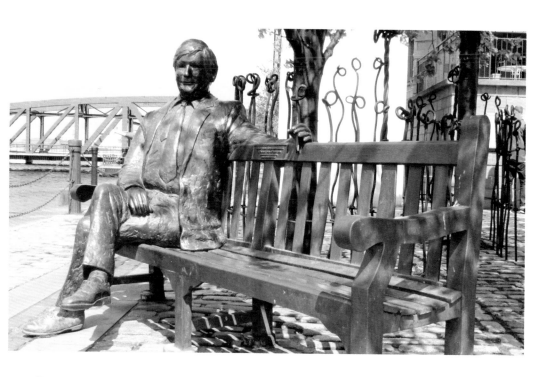

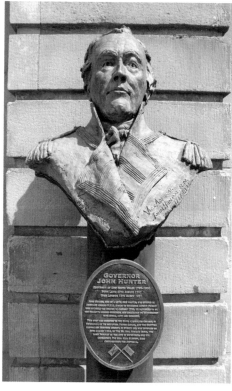

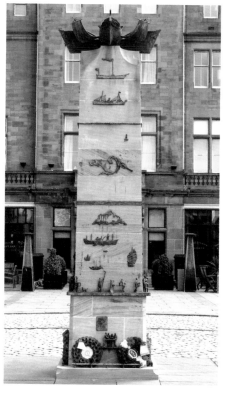

What stands before you commemorates the sacrifice by over 6,500 British Merchant Navy personnel from Scotland in the two World Wars, all other losses in previous and subsequent theatres of conflict and in peacetime duties along the trading routes of the World.

It was unveiled on 16 November 2010 by Her Royal Highness Princess Anne, patron of the Merchant Navy Memorial Trust Scotland.

Edward VII Statue, Victoria Park, Newhaven Road
The life-sized bronze statue of Edward VII was sculpted by John Stevenson Rhind in 1913. It is inscribed: 'Peace. Edward VII – 1801–1910', and depicts the King dressed as a member of the Order of the Thistle.

Fountain, Victoria Park, Newhaven Road
This small fountain was unveiled in 1899. The main inscription reads: 'Presented to the Burgh of Leith by the Leith Horticultural, Industrial and Sports Society.'

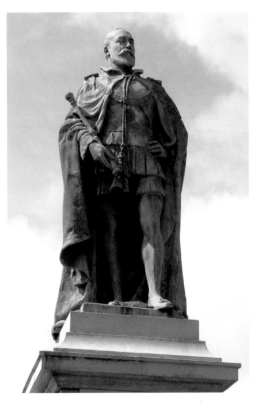 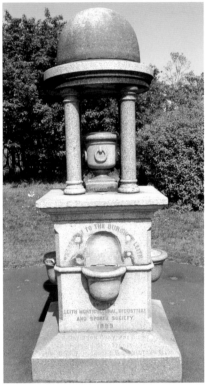

Portobello

Dr Hugh Dewar Fountain, Abercorn Park, Portobello

The fountain in Abercorn Park, Portobello commemorates Dr Hugh Dewar (1866–1914), a local physician, who is depicted in a bronze relief portait on the monument. It was designed by T. Currie Bell and unveiled in 1915. Two original carved lion's heads have been removed from the fountain. The inscription reads:

> This Fountain Has Been Erected In Remembrance of Dr Hugh Dewar Portobello By His Grateful Patients and Numerous Friends Who Deplore The Loss in the Prime of Manhood of a Kind Friend and a Skilled and Beloved Physician. His Quiet Charity Was Known To The Needy.

This is the probably the most controversial statue in Edinburgh. Dr Dewar was held responsible for the death of one of his patients during childbirth in what was a case of extreme medical incompetence. He was charged with culpable homicide and was facing civil proceedings for criminal negligence when he took his own life in April 1914. Despite this, the Dewar Memorial Committee raised £310 in four weeks for the memorial.

Coade Stone Pillars, Promenade, Portobello

Three distinctive Coade-stone pillars stand in a seating area on the Promenade in Portobello. The area was previously a disused piece of ground, which was landscaped in 2006.

The pillars date from the early nineteenth century and were rescued from the garden of Argyle House, on Portobello's Hope Lane where they had stood for many years. The reason for the pillars being in Portobello is not known; the only clue is that they are similar to the chimneys at Dalmeny House.

Coade stone, or lithodipyra ('stone fired twice' – Ancient Greek), is an artificial stone that was first created by Eleanor Coade in 1770.

Sundial, Brighton Park

Brighton Park was laid out in 1820–03 by the architect John Baxter as part of a scheme for an exclusive residential development in Portobello. The large stone sundial, topped with a thistle, dates from the eighteenth century and was originally located in the garden of Portobello Tower.

Newcraighall

The Spirit of Community Monument

The colliery that was sunk at Newcraighall in 1897 promised work and wages for 100 years, a miner's equivalent of striking gold, and the pit became known as the 'Klondyke'. The colliery closed in 1968 due to geological problems.

A stone sculpture carved with mining related motifs. The inscription reads:

From the Barren Coal Dust of Centuries of Poverty, Suffering and Sorrow toward a spirit of community that sustained our Miners and their Families in the struggle to Preserve their Mining Heritage. This monument and reborn Village shall forever bear witness to this Spirit. Unveiled by Councillor David H. Brown. J.P. on the first day of May. A.D. 1989. Commissioned by the City of Edinburgh District Council with assistance from the Scottish Arts Council.

Dr Andrew Balfour Memorial Fountain, Whitehill Street
The inscription on the fountain reads:

> Erected by the people of this district to show their rich esteem for the memory of
> Dr Andrew Balfour who for thirty years took a great interest in the welfare of this village.
> Died 28th December 1906. Erected June 1907.

Dr Balfour assisted miners at the time of a fire at the Newcraighall pit in May 1884
and in 1890 was tireless in his treatment of local people during an influenza epidemic
in the village.

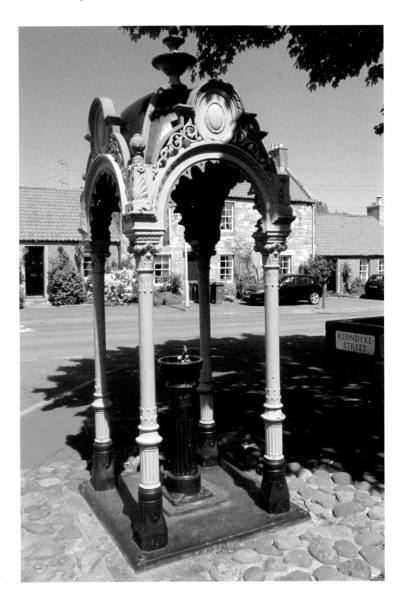

Miscellaneous Locations

St Bernard's Well, Water of Leith, Stockbridge

According to tradition, St Bernard's Well was re-discovered by three Heriot's school boys while fishing in the Water of Leith in 1760, when the mineral spring was covered by a small wellhouse. 'Claudero' (James Wilson), the contemporary poet, composed a eulogy: 'This water so healthful near Edinburgh doth rise which not only Bath but Moffat outvies. It cleans the intestines and an appetite gives while morbific matters it quite away drives.'

Chemical analysis revealed that the water was similar to the sulphur springs at Harrogate in Yorkshire. The mineral well soon became a popular resort for those afflicted by the fad for 'taking the waters'.

The Moray estates were owned by Lord Gardenstone by 1788, who claimed he had derived great benefit from drinking the waters. He commissioned Alexander Nasmyth (who later became the father of Scottish landscape painting) to design this Temple at Tivoli-inspired design after Nasmyth returned from his Grand Tour.

In 1885, the well and grounds were purchased by publisher Thomas Nelson, who donated it after restoration to the city of Edinburgh. The original Coade stone statue of Hygiea had fallen into a bad state of repair and was replaced by a new marble figure, sculpted by D. W. Stevenson. The pump-room was refurbished with Cosmati style mosaics, and the white marble pedestal is inscribed: BIBENDO VALEBIS (By Drinking You Will Be Well).

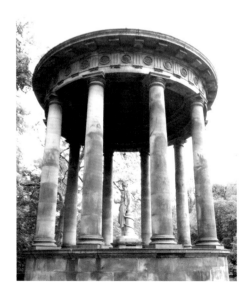

James V Statue, Braehead Mains

This statue is located in a courtyard at Braehead Mains off Queensferry Road. It was originally within the grounds of Clermiston House, which was demolished in 1970. The statue depicts James V on a rearing horse being accosted by a robber. It is inscribed: 'James V attacked at Cramond Brig AD 1532'. It was sculpted in Craigleith stone by Robert Forrest around 1836.

Robert Forrest (1790–1852) was a self-taught, Lanark-based sculptor, who began his career as a stone mason. In 1830, he exhibited various statues in Edinburgh, displayed behind the National Monument on Calton Hill.

The work illustrates the story of King James V being attacked by robbers on Cramond Brig. A local farmer, John (Jock) Howieson, stepped in to rescue the king and was rewarded with a gift of land at Braepark. The story features in Sir Walter Scott's book *Tales of a Grandfather*, and has also been captured in verse by William McGonagall:

On one occasion King James the Fifth of Scotland, when alone, in disguise,
Near by the Bridge of Cramond met with rather a disagreeable surprise.
He was attacked by five gipsy men without uttering a word,
But he manfully defended himself with his sword.
There chanced to be a poor man threshing corn in a barn near by,
Who came out on hearing the noise so high;
And seeing one man defending himself so gallantly,
That he attacked the gipsies with his flail, and made them flee.

Extract from 'An Adventure in the Life of King James V
of Scotland' by William McGonagall

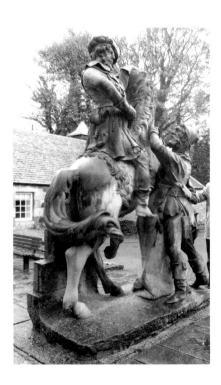

Covenanters' Monument, Redford Road

The monument at the gates of Dreghorn Barracks was erected in 1885 by Robert Macfie, the M.P. for Leith and the then owner of Dreghorn House. The monument is constructed from a cluster of four Ionic columns salvaged from the colonnade of William Adam's eighteenth-century Royal Infirmary on Infirmary Street, which was demolished in 1884.

The monument is commonly known as the Covenanters' Monument from the inscription 'Covenanters 1666' – the date of the Battle of Rullion Green – on the most prominent side of the monument. However, the other sides are inscribed: 'Charles 1745' (a reference to Bonnie Prince Charlie and the Jacobites), 'Cromwell 1650' and 'Romans.'

Miller Mausoleum (Craigentinny Marbles), Craigentinny Crescent

The Craigentinny Marbles is an imposing Roman-style mausoleum which stands amid the suburban houses of Craigentinny Crescent, just off Portobello Road in Edinburgh. The name is derived from the two sculptured panels that adorn the monument. David Rhind designed the monument and the eminent Victorian sculptor Alfred Gatley (1816–63) carved the bas-relief marbles that depict 'The Overthrow of Pharoah' and 'The Song of Miriam'. The panels were described in 1867 when they were fixed to the monument as: 'the most remarkable pieces of sculpture executed during this century' and 'attracted artists from all parts to view them'.

The monument marks the last resting place of William Henry Miller (1789–1848). Miller was a wealthy eccentric who inherited the Craigentinny Estate. He was Member of Parliament for Newcastle-under-Lyme between 1830 and 1841 and was a renowned collector of books. He was known as 'Measure Miller' from his habit of carrying around a ruler to measure the exact size of copies of books before deciding if it would enhance his collection.

Miller died in 1848, at the age of sixty, after a short illness at his estate at Craigentinny. He was not buried until six weeks after his death and this resulted in speculation about

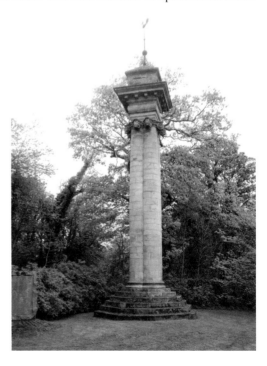

the method of his internment. Events were reported in the newspapers under the heading 'Singular Internment'. It was reported that eighty laborers had been hired to excavate a stone-lined pit 40 feet (12 metres) deep for his grave.

Rumours soon developed around the reason for the elaborate burial arrangements. It was said that Miller was 'notable for his spare figure, thin treble voice and total absence of beard', and it was suggested that Miller had been an adopted female orphan who had masqueraded as a man all his life.

Confucius and Hung Kuan, Abden House, Marchhall Crescent

Statues of Confucius and Dr Huang Kuan at the Confucius Institute for Scotland. Dr Huang Kuan was the first Chinese student to study at a Western university and graduated from the University of Edinburgh's Medical School in 1857. On his return to China, he had a distinguished medical career. He was responsible for introducing new methods of surgery to China and had an important part in the control of a cholera epidemic in Canton in 1870.

Helen Crummy Statue, Niddrie Mains Road, Craigmillar

The bronze statue of Helen Crummy MBE (1920–2011) giving a violin bow to her son was sculpted by Tim Chalk and was unveiled by Richard Demarco and Helen's grandson, Prentice Crummy, on 21 March 2014.

It commemorates the life of Helen Crummy, who was the driving force behind the internationally renowned Craigmillar Festival and was known as the 'heroine of Craigmillar'. She first set up a community art group when her son, Philip, was refused violin lessons by his school. The statue shows the moment when she was able to give her son a violin – the original violin was played at the unveiling. The statue also incorporates work by local adults and children. The inscription on the statue reads: 'Dr Helen Crummy MBE 1920–2011 Founder of The Craigmillar Festival Society. Craigmillar Now a Fine Place To Be. Women Tap the Creative Well. Let The People Sing.'

The sculpture is one of only four public statues in Edinburgh to honour women. The others are to Queen Victoria at the Foot of Leith Walk, an African woman and child at Festival Square and Catherine Sinclair at Charlotte Street North/St Colme Street.

James Watt, Heriot Watt, Riccarton Campus

The bronze statue depicts a seated figure of James Watt (1736–1819) holding a book and set of dividers. It was originally unveiled on 12 May 1854 outside of the Watt Institution and School of Arts in Adam Square. After the unveiling, staff and students met at the Guildford Arms pub and formed the Watt Club, to honour the memory of James Watt. The statue was later moved to outside of Heriot-Watt College in Chambers Street, and in 1991 to Heriot-Watt University's Riccarton Campus.

James Watt, the celebrated Scottish engineer and inventor, was born in Greenock in 1736. His improvements to steam engine machinery did much to fuel the Industrial Revolution.

The fine landscaped grounds of Heriot-Watt University's campus at Riccarton contain a number of high quality modern sculptures. The university also owns another statue of James Watt, which is on display at the National Portrait Gallery on Queen Street.

Grange Wyverns, Grange Loan

This ornately carved column was one of a pair that once stood in the grounds of Grange House – the other is set into a wall some 100 metres to the east on Grange Loan. The columns were moved to their present location when Grange House was demolished in 1936. They are surmounted by wyverns – mythical creatures with a dragon's head and wings, a reptilian body, a barbed tail, a venomous bite and the ability to breathe fire. Wyverns formed part of the coat of arms of the Seton family, who were linked to the Dick Lauders of Grange House during the eighteenth century.

King Tom, Dalmeny House

King Tom (1851–78) was a British thoroughbred racehorse and a top breeding stallion for Baron Mayer de Rothschild's stud at Mentmore. King Tom's offspring included the winners of the Oaks, the Derby and the St Leger. King Tom died at age twenty-seven in January 1878. He was buried in the grounds of Mentmore, beneath the life-sized bronze statue by Sir Joseph Boehm. The Mentmore Estate came into the possession of the Roseberrys of Dalmeny through marriage and the statue was moved to Dalmeny in June 1981.

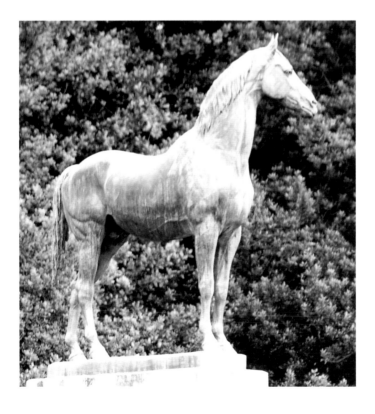

Alan Breck and David Balfour Statue, Corstorphine Road

We came the by-way over the hill of Corstorphine, and when we got near to the place called Rest-and-be-Thankful, and looked down on Corstorphine Bogs and over to the city and the castle on the hill, we both stopped.

The statue of Alan Breck and David Balfour, heroes of Robert Louis Stevenson's book *Kidnapped*, depicts the moment that they finally parted ways on Corstorphine Hill, near the end of the book. It was sculpted by Alexander Stoddart and unveiled in September 2004 by Sir Sean Connery.

Robert Louis Stevenson, Dell Road, Colinton

The statue of Robert Louis Stevenson as a boy with his dog, by Alan Beattie Herriot, outside Colinton parish church, was erected by the Colinton Community Conservation Trust. It was unveiled on 26 October 2013 by Ian Rankin, author of the Rebus books. Stevenson often stayed with his grandfather, Dr Lewis Balfour, the minister of Colinton parish church, and based many of his poems in the *Child's Garden of Verses* on his boyhood in Colinton. The statue shows the author with two books, reflecting his habit of always having 'one to read, and one to write in'.

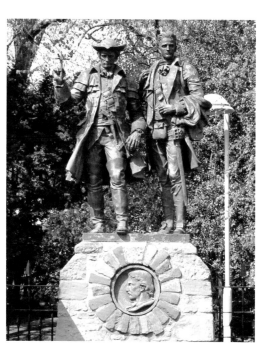
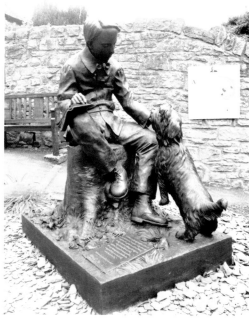

Forth Bridge Memorial

A 7-foot-high (2.1 metres) bronze memorial to the seventy-three men who died building the Forth Rail Bridge and to celebrate all the people that have worked on the dangerous job of maintaining the bridge. The monument is engraved with the words: 'To the Briggers, past and present, who built, restored and continue to maintain this iconic structure'. The memorial by local artist Gordon Muir was unveiled on 18 May 2012 by First Minister Alex Salmond.

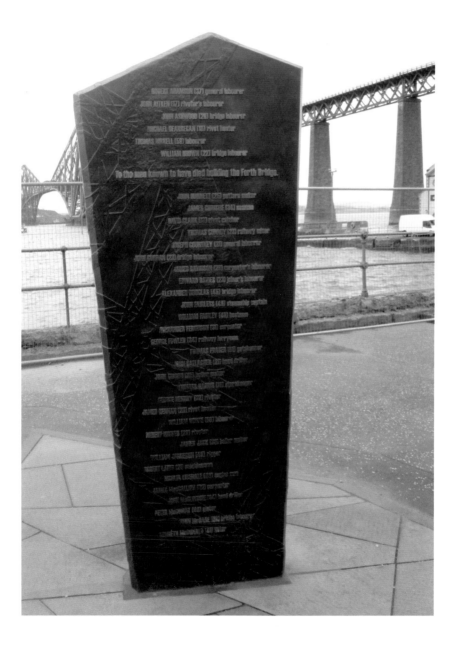